D1379497

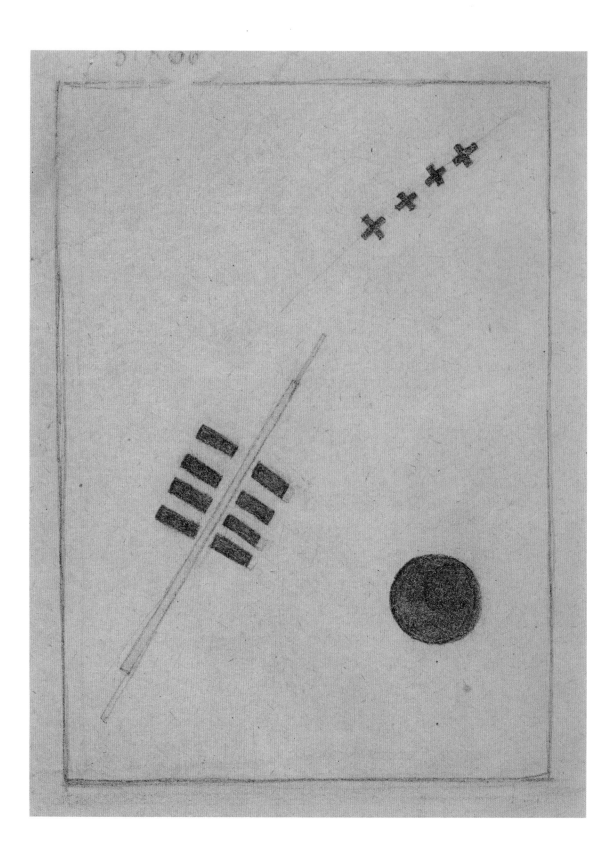

In Pursuit of the Invisible

Selections from the Collection of Janice & Mickey Cartin
An Exhibition at the Loomis Chaffee School

Foreword by Mickey Cartin
Essay by John Yau

Published by Hard Press
West Stockbridge, Massachusetts

This catalog is published on the occasion of the exhibition *In Pursuit of the Invisible, Selections from the Collection of Janice and Mickey Cartin*, at The Sue and Eugene Mercy, Jr. Gallery, The Richmond Art Center, The Loomis Chaffee School, Windsor, Connecticut, May 20-June 15, 1996

All photography by Ed Thomas Photography, except as follows: frontispiece courtesy Leonard Hutton Galleries; page 22: George Adams Gallery; page 23: Gagosian Galleries; page 24: Robert Miller Gallery; page 30, 31: C&M Arts; page 32: Pace Gallery; page 33: ACA Galleries; page 34, 36, 62, 76: Janet Fleisher Gallery; page 40: Forum Gallery; page 48: Richard York Gallery; page 52, 63: Phyllis Kind Gallery; page 70: Jack Tilton Gallery

Catalog design and production by Les Ferriss

Printed in Hong Kong through
Acid Test Productions, Petaluma, California

Library of Congress Cataloging-in-Publication Data

In pursuit of the invisible: selections from the collection of Janice & Mickey Cartin exhibited at the Loomis Chaffee School / foreword by Mickey Cartin: essay by John Yau.
 p. cm.
 ISBN 0-9638433-9-7 (alk. paper)
 1. Art, Modern—20th century—Exhibitions.
 2. Art—Private collections—United States—Exhibitions.
 3. Cartin, Janice—Art collections—Exhibitions.
 4. Cartin, Mickey—Art collections—Exhibitions.
 5. Loomis Chaffee School. I. Cartin, Janice. II. Cartin, Mickey. III. Loomis Chaffee School.
 N6488.5.C37I6 1996
 709'.04'00747462—dc20 96-17391
 CIP

Hard Press, Inc.
P.O. Box 184
West Stockbridge, MA 01266

Front cover
Alfred Jensen, *My Universe, a Oneness of Colours*, 1957
Oil, canvas, 26 x 22 inches

Back cover
Wes Mills, *Airstream*, 1981
Graphite, colored pencil, paper, 3.75 x 4.125 inches
(reproduced actual size)

Frontispiece
Kasimir Malevich, *Cosmos*, 1917
Pencil, paper, 7 x 5.25 inches

Foreword

This exhibition, and all the years of searching, questioning, doubt and exaltation that preceded it, is a tribute to all artists. Art exhibitions in almost every case, if they turn out to be nothing else, are at the very least a tribute of sorts to the artist whose work is being exhibited. In the life of a committed artist art occupies an absolutely necessary position. That is, not only the making of art, but because of its often mysterious way of giving pleasure, its transformative capacity, and its probing, palliative quality, art fulfills a powerful need in the artistic mind and spirit that can be satisfied in no other way. Of course, all artists are not represented here, and it may seem odd that I see this as a tribute to every one of them, but it is through the endeavor and pursuit of all true artists that I have come to recognize in myself the same mixture of both ennobling and abject need, and I am quite grateful for this.

The works in this exhibition are intensely impassioned, philosophically challenging, and filled with mystery, miracle, and a constant thrusting emotive charge. I wonder perpetually about their meaning, and about the questing, often troubled sense of purpose from which they were born. I not only live with these things, I am drawn to them, perplexed by the questions that come to mind as I ponder them, and awed by the seductive grip in which they hold me. And in respect of their emblematic significance as attempts at possible answers to life's most elusive and therefore terrifying questions, I even permit them to frighten me from time to time. This practice serves to remind me that in spite of my reluctant view toward the institutions of western religion, my frailty as a human being requires repeated doses of hope and healing.

The thrill of living with all of these objects is exceeded only by the great pleasure and privilege I have had of getting to know and befriending a number of these artists, and to them I am particularly indebted. I see them as truly committed people, creating and sharing their abundance of miraculous objects and ideas with me, my family, and the rest of the world. My life has been deepened and transformed through my relationship with these people, and I cannot adequately express my gratitude here except for the modest tribute I pay them by way of this exhibition, and perhaps with these few thoughts. I must thank:

Joe Coleman for the frequent invitations to his studio/"odditorium"/ museum of death, and for sharing with me his unique, ominous yet hopeful notion of human nature.

Paul Laffoley, who has captivated me with his brilliant, indecipherable diagrams of the universe, and who has spent hours mesmerizing me with his fascinating, yet often equally inscrutable explanations of his work and his very own laws of nature.

Walton Ford for sharing his great enthusiasm for art, and his great talent for painting.

Sam Messer for not ever sitting still, for never running out of ideas, and for sharing with me his very generous interest in the work of other artists.

Wes Mills, whose fragile nature and unstoppable search for the aesthetic paradigm has taught me a new way of seeing and feeling.

Greg Gillespie for sharing so many secrets, and for allowing me to witness so frequently the unique genius of his painting in progress.

And very special thanks to Tony Fitzpatrick for the hundreds of hours of thoughts about our world, and for the inexpressible thrill of living with so much of his work. Also, I am grateful to him for getting me to take certain matters more seriously, while teaching me to laugh so hard and freely at others that I once thought were not so funny.

I wish that I could thank Alfred Jensen and Forrest Bess for the ways in which they have opened my eyes to their own private universes. And I sit for long periods of time in front of Cornell's miniaturized worlds of fantasy, and while I never met him I somehow feel that his spirit and even his creative destiny speaks to me with a remindful resonance. And Malevich, as well, dreamed with a sense of urgency and great conviction of a future, "when entire cities and, of course, studios of modern artists would be gliding in the air, suspended on gigantic dirigibles," (from a letter dated May 9, 1913 from Malevich to M. Matyushin, and quoted in an essay by Lev Nussberg in *Malevich*, published 1995 by Leonard Hutton Galleries.)

Living with the work of these fascinating people has given me the great fortune of sharing in their dreams, and has made me realize the mistake in underestimating the importance of dreaming. I often wonder if they could have ever anticipated the magnitude of their legacy.

Through the soulful self-portraits of John Kane, now dead for over sixty years, I feel as if I were a living witness to his fascinating biography. He was a brawling, contentious, heavy drinking rogue,who worked in the steel mills and on the railroads, fought with his bare fists for one dollar prizes, all while losing a leg in a train accident and his dignity to the bottle. In addition to all of this he was also a profoundly introspective man who felt deeply his own tragic capacity for self-destruction, yet who would depict himself as a handsome, strong hero committed to the struggle and

sacrifice required for the industrial growth of his adopted homeland. Of course I know all of this from his biography, but I really feel that I know him through the expressive power of his self-portraits.

In some unexplainable way, through repeated encounters with his drawings, I have gained access to the private world of Adolf Wolfli. Of course I cannot comprehend it, and I cannot account for my specific location in time and space when I am there. But living with the work of perhaps the most inventive voyager in all of the art history gives me a unique perspective when I look back on our world. And if he could have composed some 25,000 pages of drawings, autobiographical text, and musical notation, all created from within the walls of his cell in a psychiatric hospital, and without the benefit of travel, television, or CD-ROM, why can't I, for a brief moment at least, pretend to have access to his vast, imaginary universe. After all, I have learned to dream, and I insist on this indulgence.

I have always loved ideas. Occasionally one will spring forth as my own invention, but for the most part they have come to me through grueling encounters with the work of great thinkers, or they have penetrated gradually through my long-term relationship with the great works of art in this exhibition. But more than anything, this is an exhibition of the work of the artist as explorer, inventor, and sorcerer. By living with these fantastic objects I have embarked on the most magnificent of journeys, held some of man's greatest inventions in my hands, and above all, after so many years of skepticism, I have come to believe in magic.

MICKEY CARTIN

Acknowledgements

This exhibition takes place during the last weeks of Lou and John Ratte's tenure at Loomis Chaffee School. I admire them both so much, and it is special to me that I will be there with my family as they take their leave.

The exhibition came to be through the encouragement of Walter and Marylin Rabetz, and I thank them for all of their help in making it happen.

I also thank John Yau, who writes so clearly and with such conviction. It is through his poetic interpretation of the work in this exhibition that I came to realize in words many notions that I had held myself, but could never find a way to express.

I thank Arnold and Fanchon Cartin, my parents, who encouraged me to attend Loomis Chaffee, and have helped me in many ways to pursue my dreams.

And I thank my wife Janice, and my sons Andy and Greg, who have endured my obsession, and who have overcome it to the point that they have begun to share it.

In Pursuit of the Invisible

I.

As the end of the 20th century begins dominating our horizon, and all our thinking and dreams point toward the impending closure of an age, many art world institutions and individuals have vigorously speculated about what art is vital, what will remain vital, what the next century might find useful, and what best characterizes this century. The question is not about stasis, about finding the right niche for an eminent work of art, be it painting or literature. It is not even about whether or not our heirs will read the dark enigmatic fables of Franz Kafka or look at the gracefully exultant paintings of Kasimir Malevich. Rather, more than how and why particular works embody the time in which they were made, the critical question asks that each work possess a telling feature, that is, something specifically telling about that age or moment in time. It is the very powerful telling nature of the works in this exhibition that gives them their potency and compelling presence. This inherent capacity for telling goes far beyond the anecdotal and both defines and inhabits a realm where decay, disorder, and death are no longer so threatening, and where the elusive and frightening mysteries of an invisible world become urgent subjects of an ambitious quest for the real. It could be said that what is true for all the artists in this exhibition is their commitment to live within a world where the instant can be transformed into the eternal, and that they all express the belief that it is possible for them to discover and define a place where time doesn't stand still so much as welcomes us home.

Having said this, one returns to a basic question: What do these works of art tell us about the nature of human existence during a century of wars, madness, and despair, about what it was like to be alive at a time when both small hopes and immense hopelessness filled the air? In the realm of painting, more so than sculpture, this question changes slightly: What do the immediacy of sensations and perceptions embodied in a particular painter's work tell us about the nature of human existence, about living in a finite world? But beyond whether the artist's primary vehicle is painting or sculpture, abstraction or figuration, the question these resolute individuals confront is their relationship to time's passing, to the fact that for all the power of their imagination and will, they remain individuals caught within the web of change and inevitability.

II.

It should be stated that the works presented in this exhibition do not in any way form a single, unified group. For the most part, the artists neither subscribed to any of the modernist movements such as Surrealism, nor did they fit conveniently into any particular epochal upsurge, such as Abstract Expressionism. They have largely been defined as isolated figures, individuals who marked out their own path. It is no surprise then that some of them, like Adolf Wolfli and Martin Ramirez, have been defined as "outsiders" and were considered social outcasts, and that others, like Alfred Jensen, H.C. Westermann and Jess, have been defined as "strange" and "eccentric" figures working at the margins of mainstream art.

While these terms seem to have a certain validity, they also marginalize the artists and diminish their work. Terms such as "outsider" and "eccentric" suggest that these artists have at best a tenuous relationship to mainstream art, whether it is Cubism, Abstract Expressionism, Pop art, or Minimalism. However, I would like to propose that despite such marginalizing labels, there are a number of important affinities the artists in this exhibition share. These affinities not only collapse those edifices of art history based on formal or stylistic categories such as abstraction and figuration, and their emphasis on the arbitrary hierarchy of mainstream art, but they also underscore both the ongoing centrality of their concerns and the continued vitality of their vision. I would also like to propose that the issues I've raised in this exhibition do not arise from the similarities of the work, thus making it a stylistically unified exhibition, which clearly it isn't, but from the meaning their modalities makes tangible. For not only do these artists transform the invisible and its various manifestations (infinity, the self, dreams, time's passing, mortality, and memory) into visible proof, but they also transform the imaginary into undeniable evidence.

III.

Alfred Jensen made his first mature paintings in the early 1950s, when Abstract Expressionism was in its heyday. These paintings utilized a prismatic palette, which was based on Jensen's research of Goethe's color theory, and around 1957 he began developing his theoretical diagrammatic paintings. *My Oneness, A Universe of Colours*, 1957, is a singular example from this period of Jensen's career. At the core of Jensen's work is his belief that there is a harmony which balances, as well as joins, oppositions such as male/female, light/dark, positive/negative, and unity/multiplicity.

Jensen banished randomness and chance from his work because he be-

14

lieved that there was deeper, divine order governing time and existence. Consequently, he understood his palette, which consisted of black and white (the parents of all color) and primary and secondary colors, to be an instrument of light. Instead of using a brush, which the artist believed would interrupt the connection between the light and the canvas or paper, he squeezed his color directly from the tube onto the surface. For Jensen, the "oneness" of his "self-identity" is made up of concentric circles of prismatic light and black and white. He understands light's non-material existence and paint's palpable presence to be interchangeable, that each can be transformed into the other. This understanding is for him visible evidence of one of the great, constant problems of metaphysics. He explains the invisible world in terms of the relationship of number and color, a most ambitious and ambiguous theory whose proof exists in this very painting, the accuracy of which, I might add, is not as important as the passion with which it was advanced.

In contrast to the Abstract Expressionists, particularly artists such as Barnett Newman and Mark Rothko, who worked in a reductive, essentializing manner, Jensen brought together a wide number of sources and branches of knowledge: literature, astrology, alchemy, numerical systems, the Mayan calendar, the religions of Ancient China and Egypt, and Pythagorean theory, among them. One of the forces connecting all of these studies together is Jensen's belief in Goethe's color theory, which was more mystical than scientific. For both Goethe and Jensen, all light (color) is symbolic. Within Jensen's world view, no distinction can be made between fact and theory.

Forrest Bess, like Alfred Jensen, believed that opposites, particularly male/female, could be unified. And like Jensen, though in a very different way, Bess was determined to reinvest symbols with resonant meaning. Bess believed it was possible for him to recover the mythical realities that are an inextricable part of archaic and preliterate signs. In an article he published in his local paper in 1951, Bess wrote: "I term myself a visionary artist for lack of a better word. Something seen otherwise than by ordinary light. I can close my eyes in a dark room and if there is no outside noise or attraction, plus, if there is no conscious effort on my part – then I can see colors, lines, patterns, and forms that make up my canvases. I have always copied these arrangements without elaboration."

For Bess, the "colors, lines, and patterns" bubbling up into his consciousness were symbols which proved the existence of the collective unconscious linking all human beings together throughout time. For Bess, and

this is something he shares with Jensen, both color and image are symbolic and irrefutable proof. There are signs for the male and female parts of the body. The linear marks are a way of counting time. A young woman is a crescent moon, which may be placed inside a sun-like symbol, which stands for man.

In *Untitled*, 1959, the central image occupying the top third of the painting can be read as a phallus; the radiating circle can be read as an anus; and the triangles can be read as cuts, which were Bess's sign for the transformation of the male into a hermaphrodite, the ideal figure embodying male and female aspects. For Bess, who claimed he did not elaborate upon his visions, every daub and smear of paint has meaning. Paint is both a substance and an instrument for making the invisible visible.

IV.

While the paintings of Joe Coleman and the drawings of Tony Fitzpatrick are very different than those of Alfred Jensen and Forrest Bess, these younger artists share a number of things with their older counterparts: a belief in associative thinking, which is one aspect of imagination; an unlikely combination of disparate images and symbols; a density to their work that is born out of necessity rather than a desire to elaborate.

In his painting, *At Home with Dian*, 1992, Coleman depicts himself and his companion sitting on a Balinese couch, which is as detailed and symbolic as any chair done by the Northern Renaissance painter, Rogier Van der Weyden. On the wall to the left of Dian is Coleman's painting of a painting of the Madonna, while on the wall to the right of him is his depiction of a more demonic self. The border of the painting is made of magical signs, which evokes his desire to protect the fragility of their domestic situation. For Coleman, partnership with another defines itself on a secular as well as symbolic level.

In the drawing, *The Angel of Luna Park*, 1991, Tony Fitzpatrick both pays homage to his wife, Michele, and evokes her mythic, restorative powers. Her dense black hair and the night sky illuminated by the constellations are interchangeable, while her blouse and a sky full of guardian birds are collapsed together. The various sentences and sentence fragments read like lines from a love poem, both breathless in their directness and highly charged in their use of metaphor. The smudges and erasure that obscure some of the words evoke both the desire to declare his feelings as well as a need for privacy, love being a matter of both. Fitzpatrick, who in addition to being an artist is also a poet, incorporates a charged language of praise.

The "Angel of Luna Park" is the presiding spirit of a place that is at once real and mythical, banal and magical, ordinary and fabulous.

V.

Wes Mills's work is simultaneously austere and expressionistic, suggesting that he has both transformed and synthesized aspects of Minimalism and the distortions of Francis Bacon into something all his own. Although his works are small in scale, he is capable of conveying vast, often desolate landscapes. In *Airstream*, Mills depicts a mobile home that tilts forward, as if it has settled unevenly into the ground. In the foreground he has made a slightly tilting, dense, elongated rectangular shape out of black lines rising from the middle of the drawing's bottom edge. The shape can be read either as a tree stump or as a road which never reaches the Airstream.

Mills's juxtaposition of a small image and a larger abstract shape endows the drawing with an atmosphere of intense isolation. The unmarked areas of the paper become a wintry landscape, which seems as symbolic as it is referential. Mills's terse drawings are both reticent and volcanic personal touchstones, as well as evocations of a fragmented world ruled by imagination and an unabated sense of terror: – a flashlight – a knife – a bridge – a cake; fetishistic emblems of a late 20th century shaman.

VI.

Although none of the artists work in a reductive or essentializing manner, all of them seem to share with Bess a refusal to elaborate upon their visions, make them decorative and thus diminish their initial power. In addition, all of them utilize juxtaposition, the placing in proximity of disparate signs, images, and things, to evoke the meaning they are after. The subject may be the body, as it is for Bess, Bill Jensen, Jean-Michel Basquiat, and Anna Zemankova; the turbulent nature of love and domesticity, as it is for Coleman, Fitzpatrick, Mark Greenwold and Gregory Gillespie; or the inevitable isolation to which every individual must eventually succumb, as it is for John Kane, Wes Mills, Jenny Scobel, and Robert Lostutter. The intersection of utopia and dystopia form the subject of James Barsness's *The Tower*, 1993, Paul Laffoley's *The Allegory Of The Cave, The Line, And the Sun*, 1991, and Chris Hipkiss's *An Isolation: A Worrying Reason To See Me*, 1995, while the binary opposition of the secular and sacred can be found in works which cut across stylistic differences and mediums and is perhaps so succinctly expressed in the untitled drawing of Leonid Purygin. Time's passing is directly addressed in the sculptures of

Bruce Conner and George Herms, while ecological destruction is central to Walton Ford's painting, *A Guilty Cock #1*, 1994. Finally, in the work of Joseph Cornell, James Lloyd, Adolf Wolfli, Martin Ramirez, Friedrich Schröder-Sonnenstern, and Joseph Yoakum, the viewer encounters self-contained worlds which work in vigorous opposition to the one we routinely inhabit. These worlds challenge our notions of what constitutes the real. The work in this exhibition articulates this in many diverse and provocative ways, all of which probes the visible in pursuit of the invisible.

VII.

We are forever on the brink of the apocalypse. This is what our contemporary age shares with the Middle Ages, the recognition that peace and harmony, such as they exist, are only temporary, that something horrible and unexpected can occur at any moment, whether to an individual, a community, a nation, or the world. The coming of the end of the world is announced periodically in supermarket tabloids, while the end of a way of life is lamented by many politicians. Time's passing deeply affects us all. However, to recognize that one is caught in time is a fact nearly everyone tries to avoid confronting.

So how is it then, after the political leaders fail us, and the fast-talking evangelists leave us with broken spirits and suitcases filled with doubts, that the work of the people in this exhibition can actually heal in the face of the apocalypse. After all, they are only artists, and at that, their work is not so easy to recognize as beautiful.

In the first "Duino Elegy," Rilke asked who would hear him if he called out. He knew that in order to truly recognize beauty, one had to also acknowledge the existence of terror. It is this duality that is inherent in the works in this exhibition. It is a duality which is central to our perceptions, whether we recognize it or not. These artists believe there is more to the world than the eye can see. The proof they offer us, "a terrible beauty" as Yeats called it, is in their art.

JOHN YAU

Checklist of the Artists

21 Hannelore Baron, born 1926, Germany; died 1987, New York

22 James Barsness, born 1954, Bozeman, Montana; lives in Venice, California

23 Jean-Michel Basquiat, born 1960, New York; died 1988, New York

25 Peter Attie (Peter Charlie) Besharo, born 1899, Syria; died 1960,
 Leechburg, Pennsylvania

26 Forrest Bess, born 1911, Bay City, Texas; died 1977, Bay City, Texas

28 Joe Coleman, born 1955, Norwalk, Connecticut; lives in Brooklyn

29 Bruce Conner, born 1933, Macpherson, Kansas; lives in San Francisco

30 Joseph Cornell, born 1902, Nyack, New York; died 1972, Queens

33 Alan Davie, born 1920, Grangemouth, Scotland; lives in London

34 Tony Fitzpatrick, born 1958, Chicago; lives in Chicago

38 Walton Ford, born 1959, Croton, New York; lives in New York

39 Gregory Gillespie, born 1936, Roselle Park, New Jersey; lives in
 Belchertown, Massachusetts

41 Mark Greenwold, born 1942, New York; lives in Albany, New York

42 George Herms, born 1935, Marin County, California; lives in Los Angeles

43 Chris Hipkiss, born 1964, London; lives in London

44 Alfred Jensen, born 1903, Guatemala; died 1981, New Jersey

46 Bill Jensen, born 1945, Minneapolis, Minnesota; lives in Brooklyn

47 Jess, born 1923, Long Beach, California; lives in San Francisco

48 John Kane, born 1860, Calder (Glasgow), Scotland; died 1934, Pittsburgh

50 Paul Laffoley, born 1940, Boston; lives in Boston

51 James Lloyd, born 1906, Cheshire, England; died ca. 1973, London

52 Robert Lostutter, born ca. 1940, Chicago; lives in Chicago

 Kasimir Severinovich Malevich (frontispiece) born 1878, Kiev, Ukraine;
 died 1935, St. Petersburg

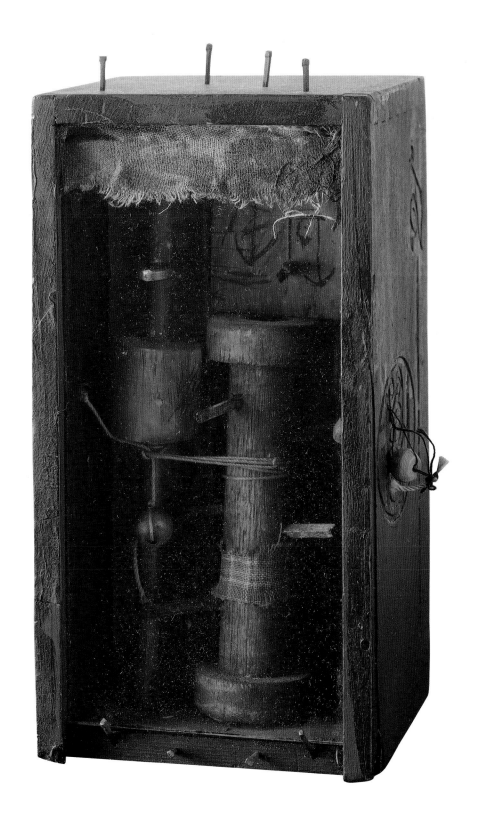

Hannelore Baron, *Untitled*, 1971
Mixed media box construction, 7 x 3.75 x 3.5 inches

21

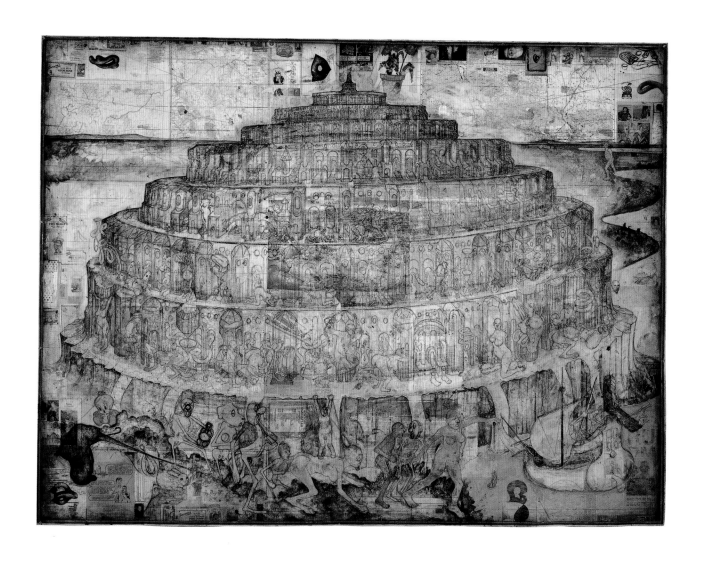

James Barsness, *The Tower,* 1993
Ink, acrylic, paper, mounted on canvas, 84 x 110 inches

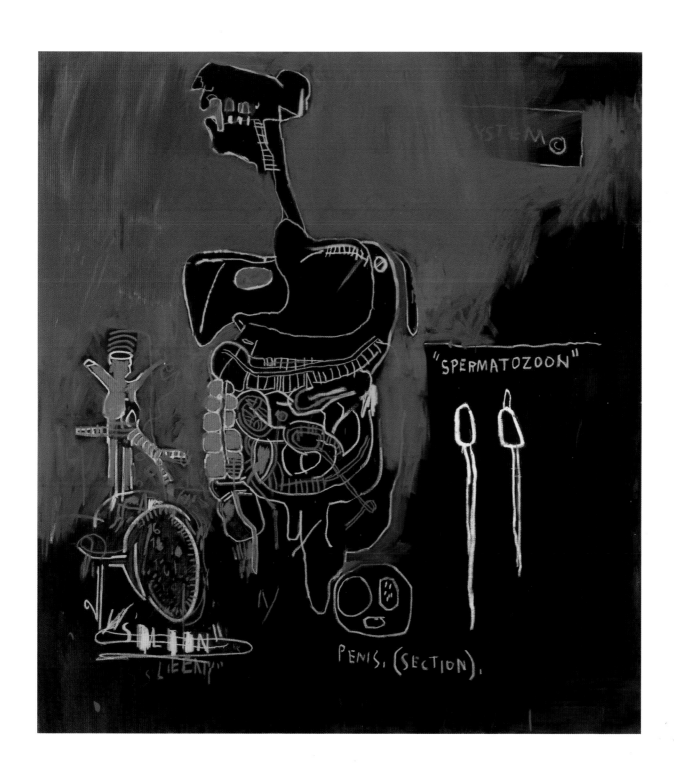

Jean-Michel Basquiat, *Untitled (Spermatozoon)*, 1983
Acrylic, oilstick, canvas, 66 x 60 inches

23

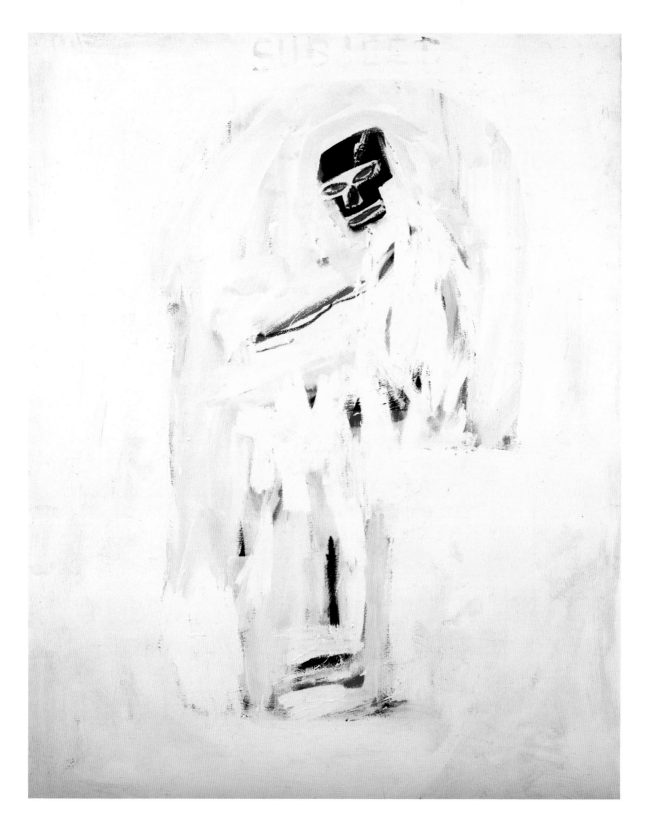

Jean-Michel Basquiat, *Untitled (Subject)*, 1985
Acrylic, oilstick, canvas, 60 x 48 inches

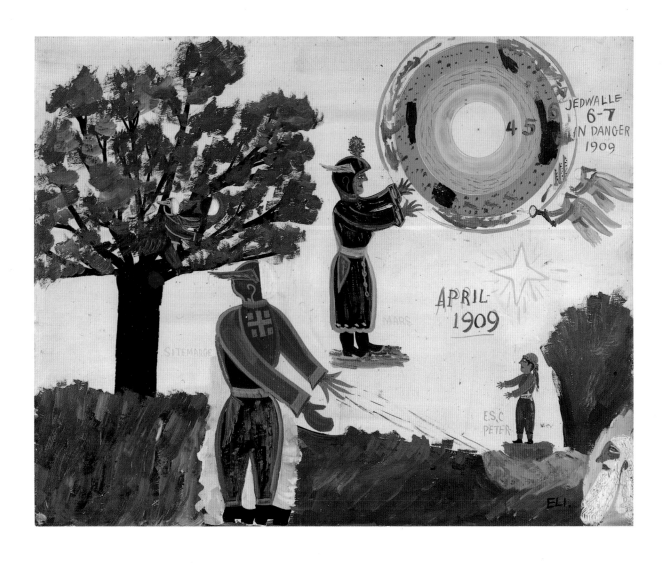

Peter Attie (Peter Charlie) Besharo, *Jedwalle in Danger*, ca. 1950
Enamel, cardboard, 22.5 x 28 inches

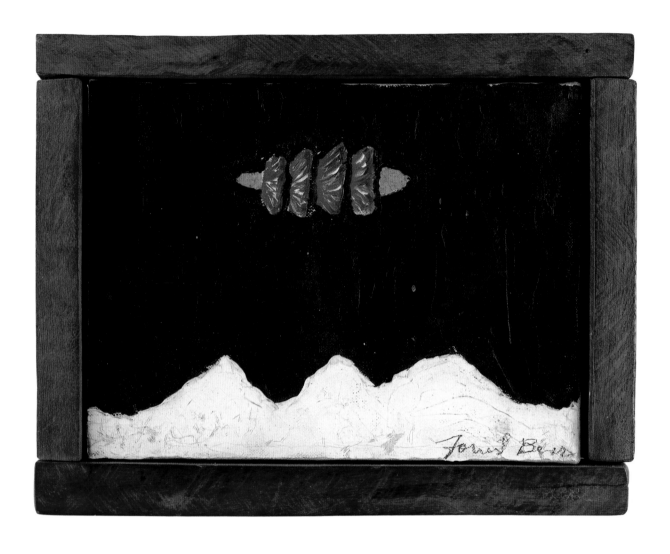

Forrest Best, *Untitled*, 1950
Oil, canvas, artist's frame, 7.75 x 9.75 inches

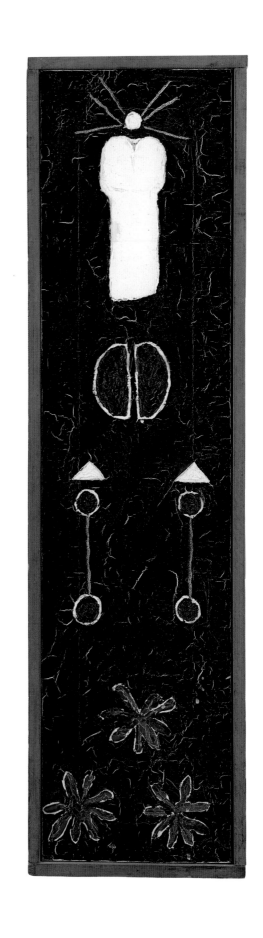

Forrest Bess, *Untitled*, 1957
Oil, canvas, artist's frame, 27.75 x 7 inches

27

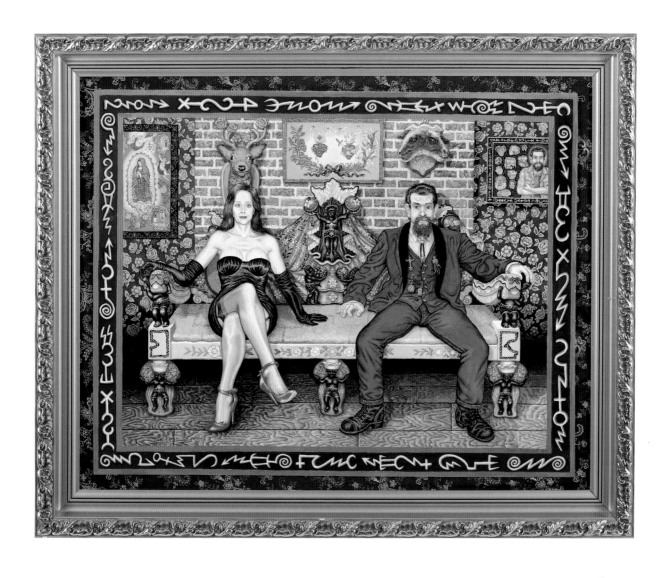

Joe Coleman, *At Home with Dian,* 1992
Acrylic, board, artist's mount and frame, 26 x 32 inches

28

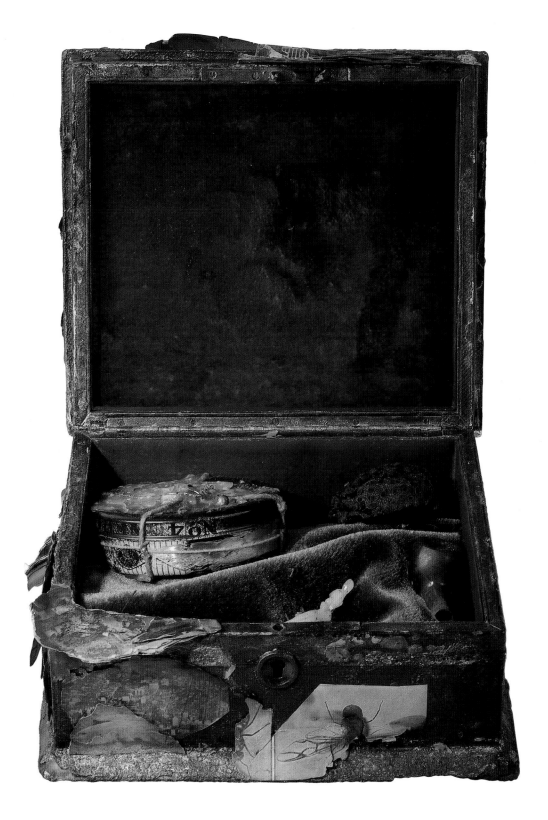

Bruce Conner, *Untitled*, 1961
Mixed media box, 7.5 x 8 x 4.75 inches

29

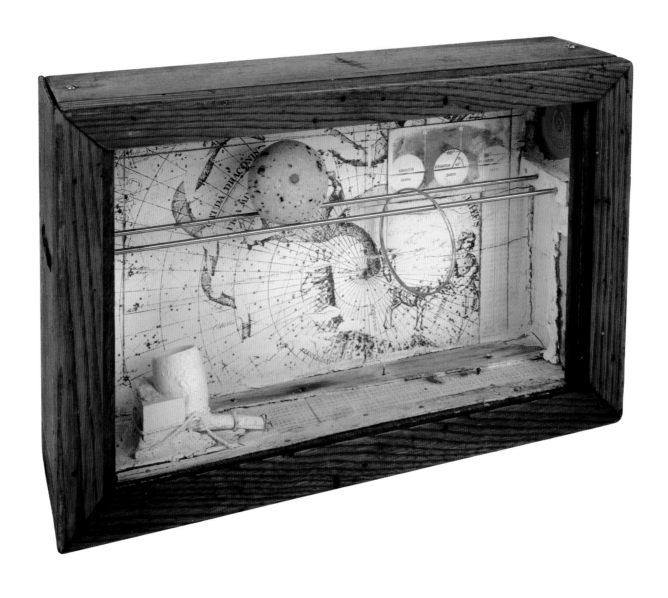

Joseph Cornell, *Untitled (Cauda Draconis Constellation)*, 1956-58
Mixed media box construction, 9.5 x 14.25 x 4.25 inches

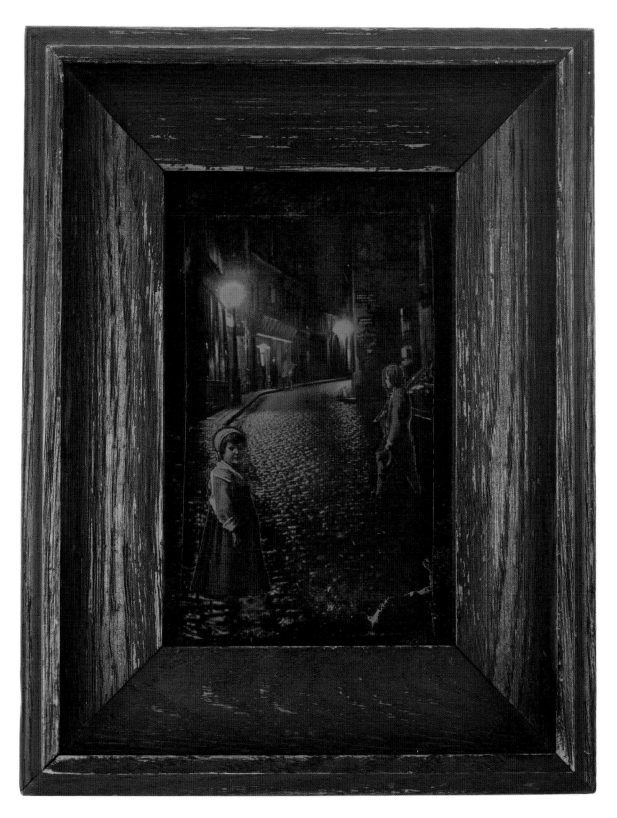

Joseph Cornell, *Untitled*, ca. 1960
Collage, artist's frame, 5.5 x 3.5 inches

31

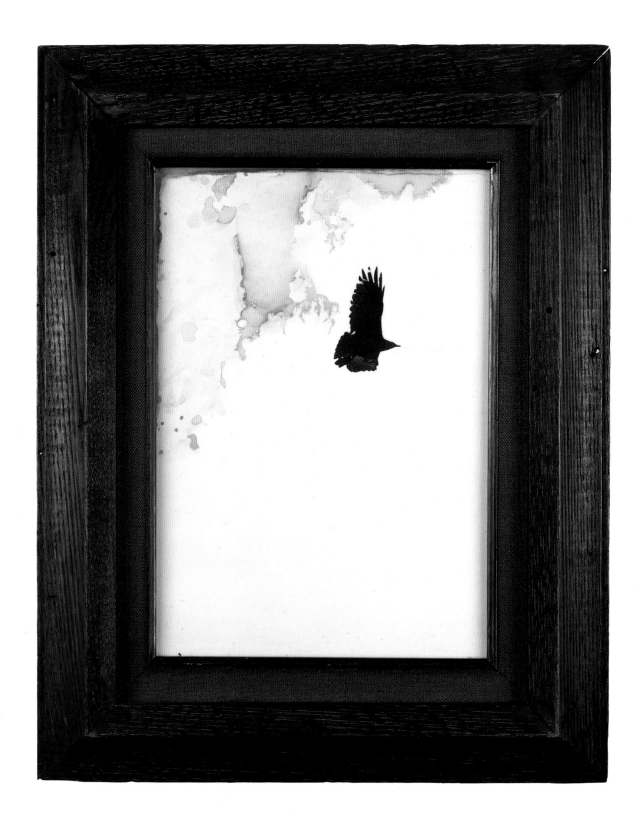

Joseph Cornell, *Untitled*, 1970
Collage, artist's frame, 9.5 x 6.25 inches

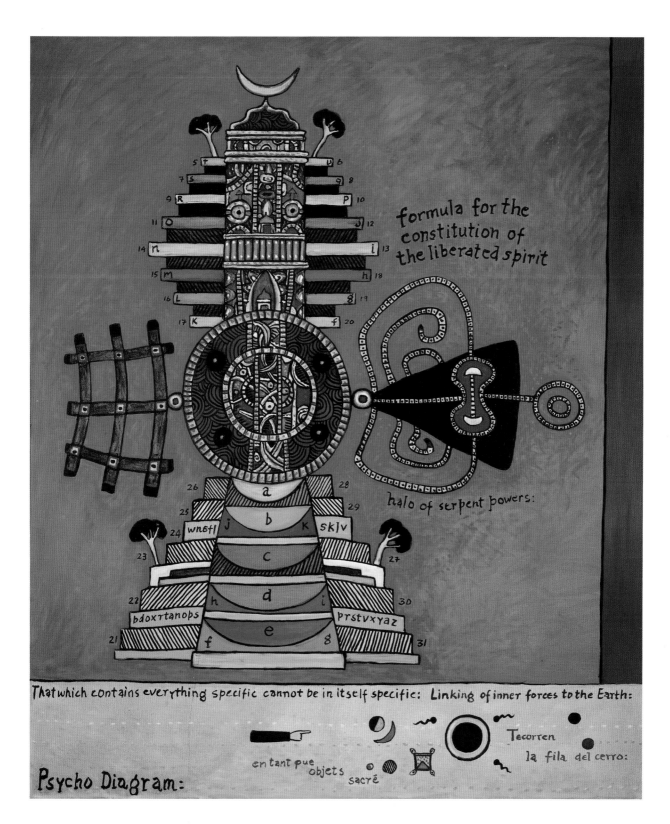

Alan Davie, *Formula for the Constitution of the Liberated Spirit,* 1992
Oil, canvas, 72.5 x 60 inches

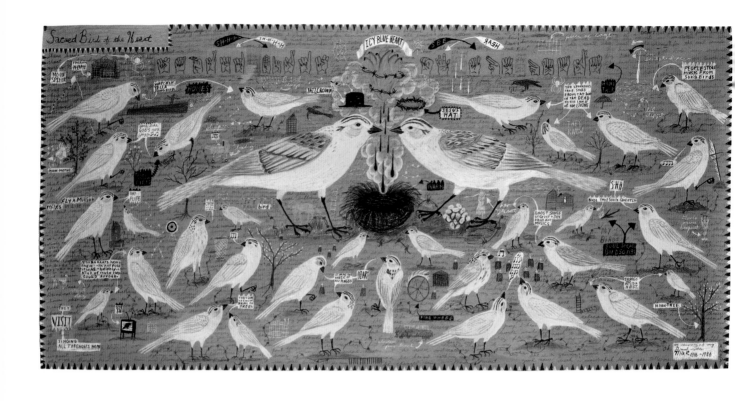

Tony Fitzpatrick, *Sacred Birds of the Heart*, 1990
Colored pencil, paper, 24 x 49.5

34

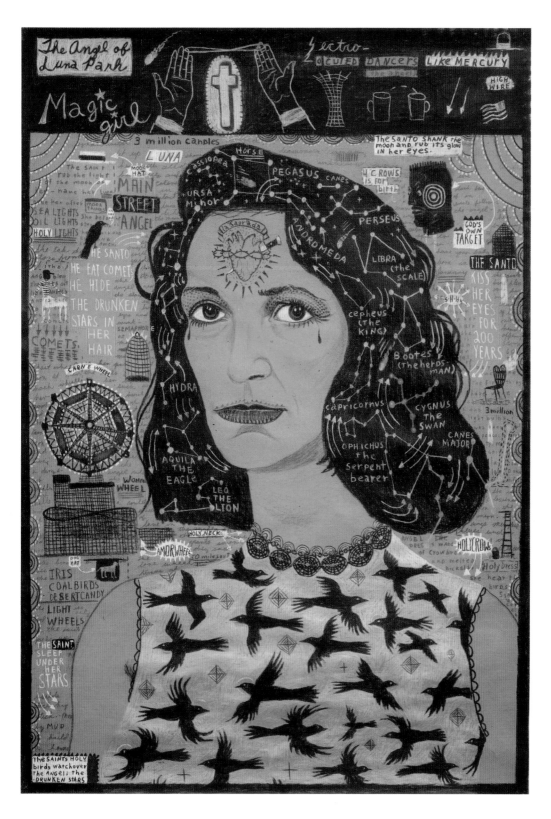

Tony Fitzpatrick, *The Angel of Luna Park*, 1991
Colored pencil, paper, 31 x 21 inches

35

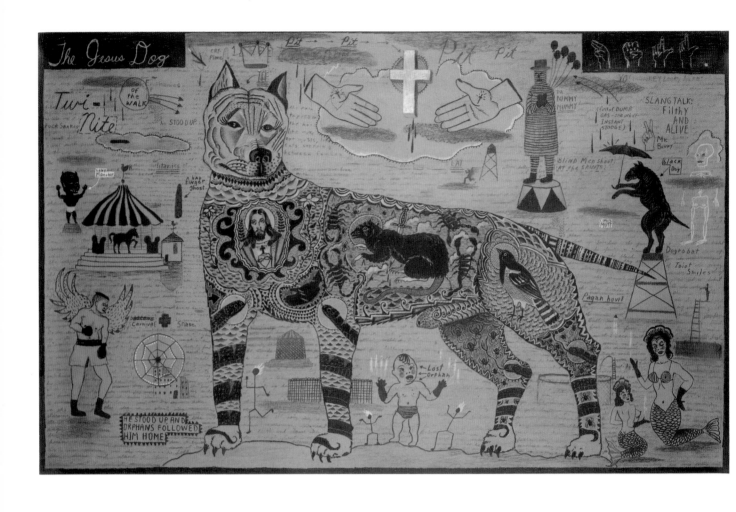

Tony Fitzpatrick, *Jesus Dog*, 1991
Colored pencil, paper, 26.5 x 46.75 inches

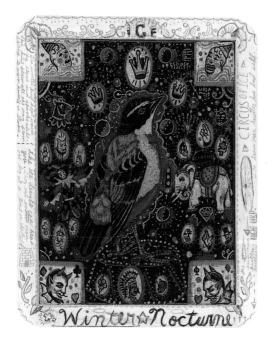
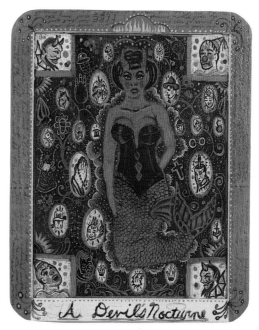
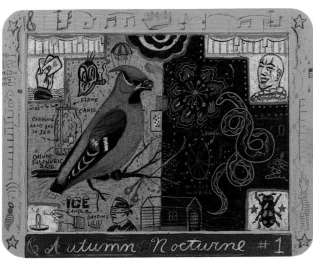
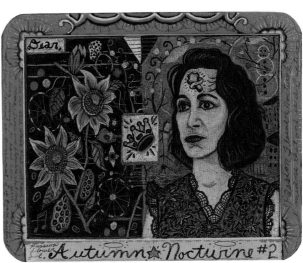

Tony Fitzpatrick, *Winter Nocturne*; *A Devil's Nocturne*; *Autumn Nocturne #1*; *Autumn Nocturne #2*, 1993
Colored pencil, slate, 9.75 x 7.75 inches / 7.75 x 9.75 inches

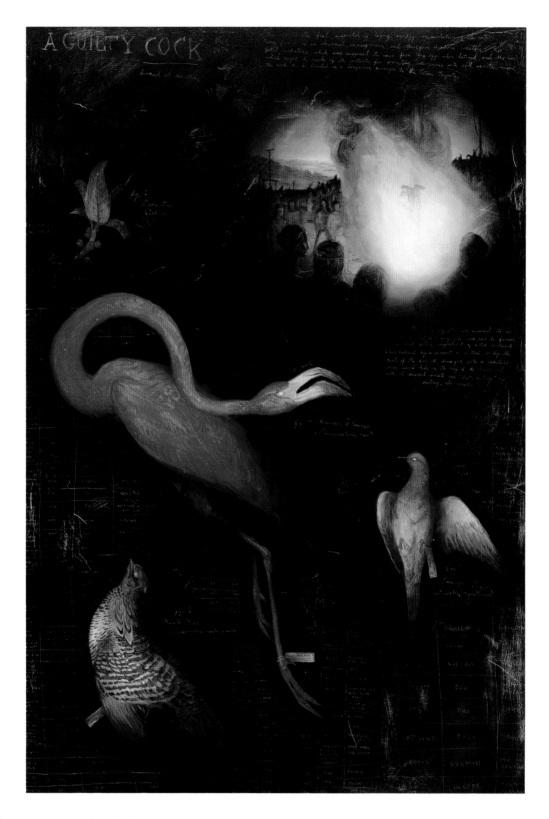

Walton Ford, *A Guilty Cock #1*, 1994

Oil, wood panel, 60 x 40 inches

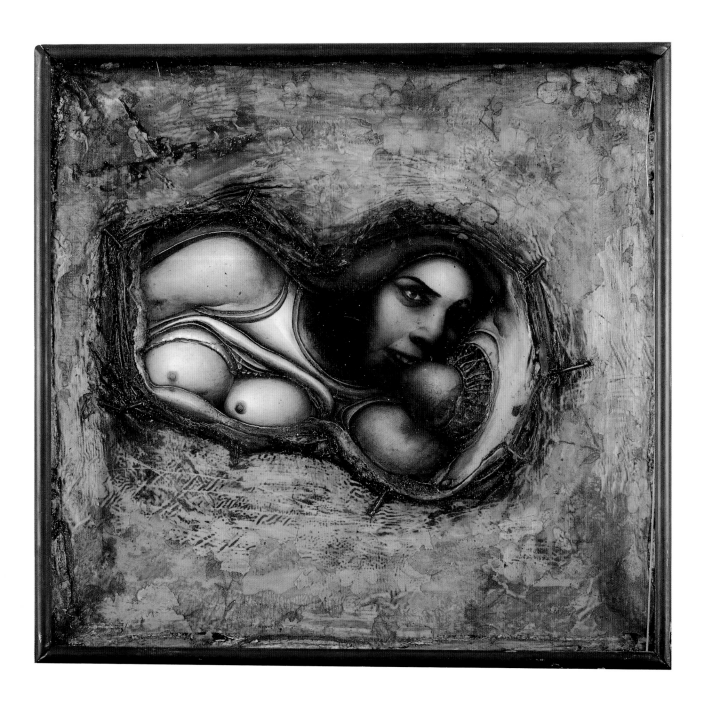

Gregory Gillespie, *Female Enclosed*, 1967
Oil, canvas, box, 9 x 9.5 x 3.5 inches

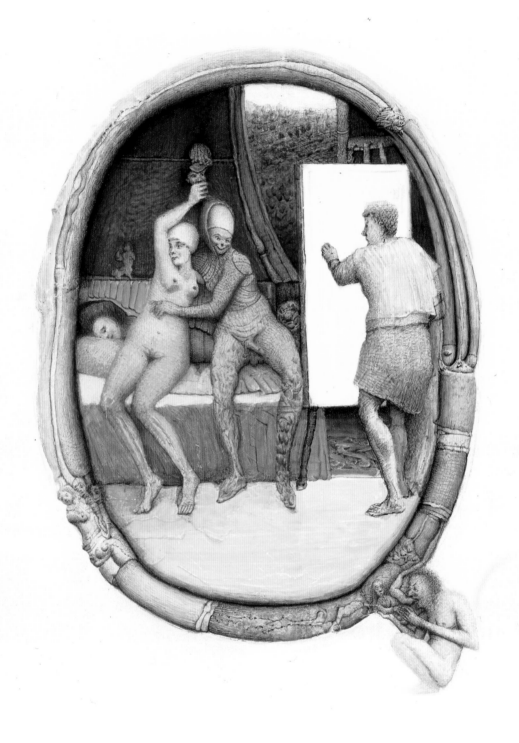

Gregory Gillespie, *Painter in Bedroom*, 1994
Oil, board, 28 x 26.5 inches

40

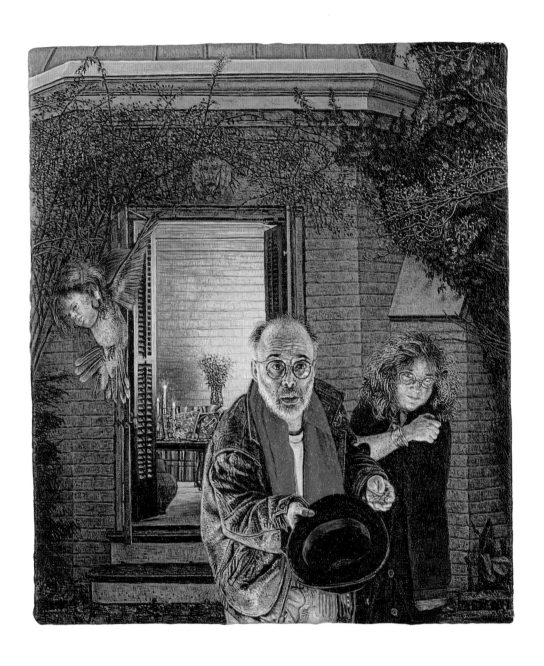

Mark Greenwold, *Enough Already*, 1994
Oil, linen, 6 x 5 inches (reproduced actual size)

41

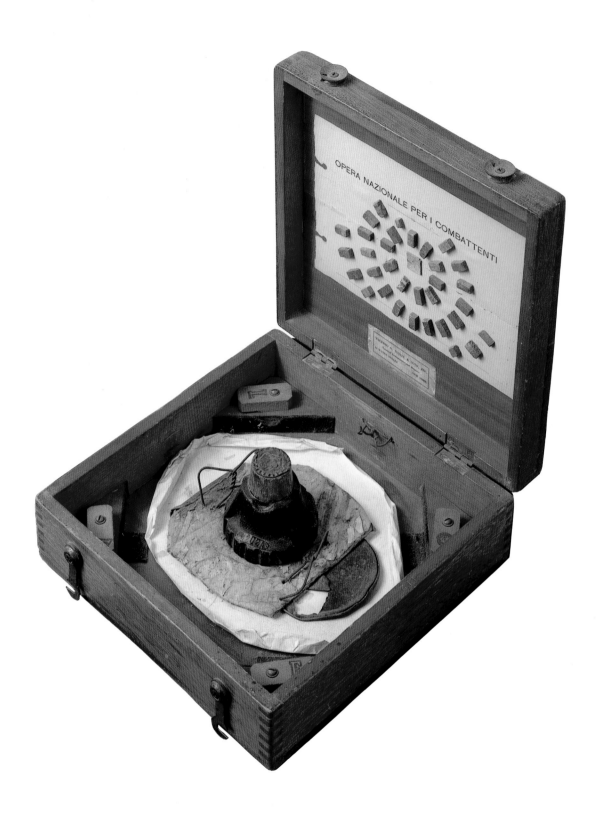

George Herms, *Untitled (Rome Poem)*, 1990
Mixed media box assemblage, 16 x 11 x 5 inches

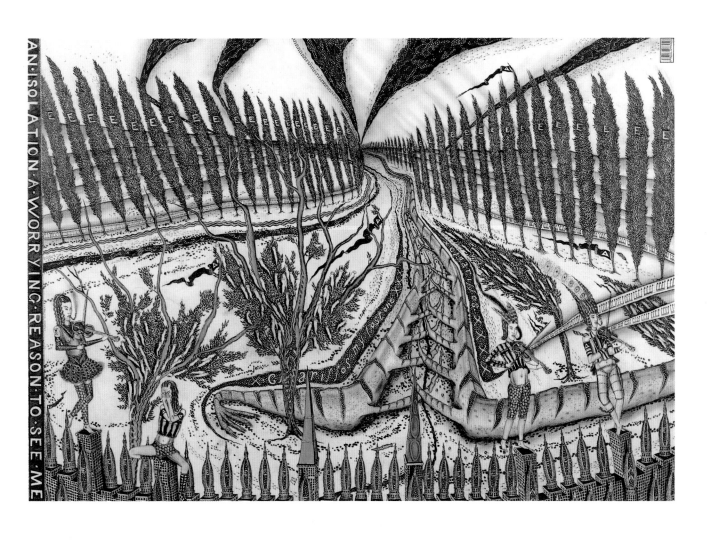

Chris Hipkiss, *An Isolation: A Worrying: A Reason to See Me*, 1995
Graphite, paper, 22 x 31.25 inches

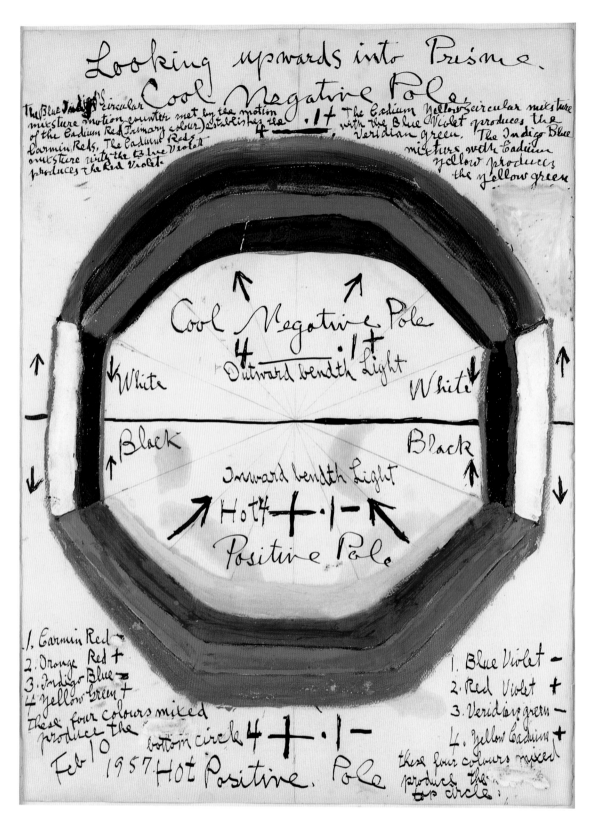

Alfred Jensen, *Looking Upward Into Prisms,* February 10, 1957
Oil, ink, graphite, paper, 30 x 22 inches

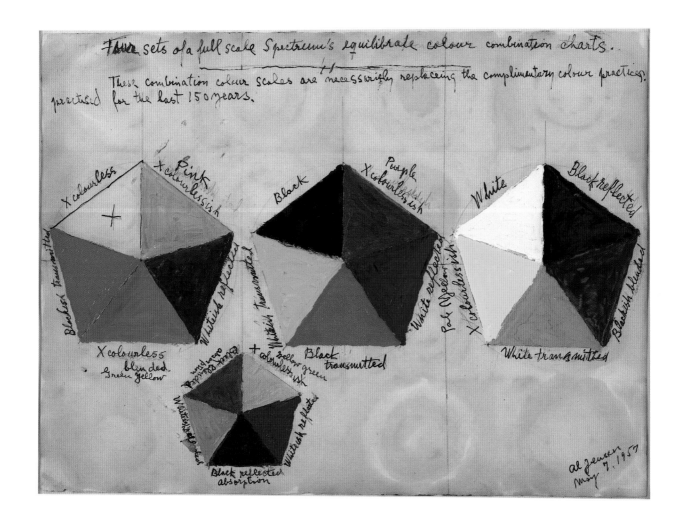

Alfred Jensen, *Four Sets of a Full Spectrum*, May 7, 1957
Oil, ink, graphite, paper, 21.5 x 29.5 inches

45

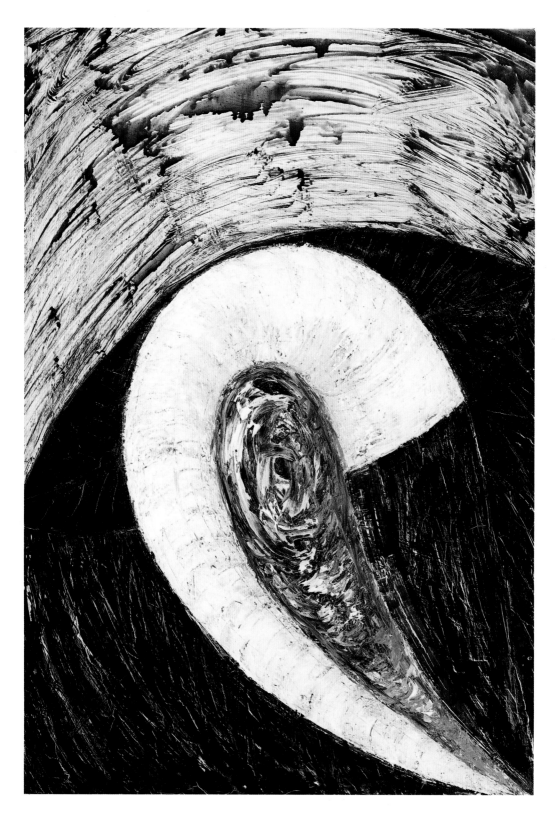

Bill Jensen, *White Heat*, 1978-79
Oil, linen, 22 x 16 inches

46

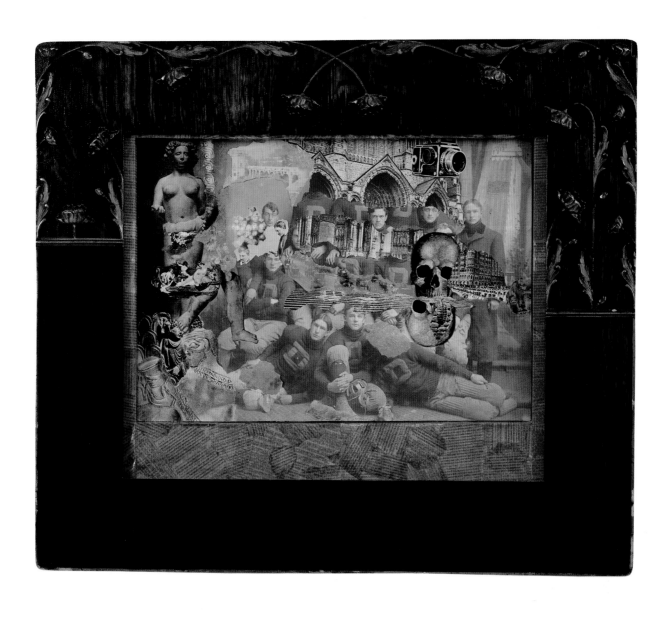

Jess, *Chiron's Souvenir for the Arco's Crew*, 1960
Paper, photo collage, artist's mount and frame, 24 x 28 inches

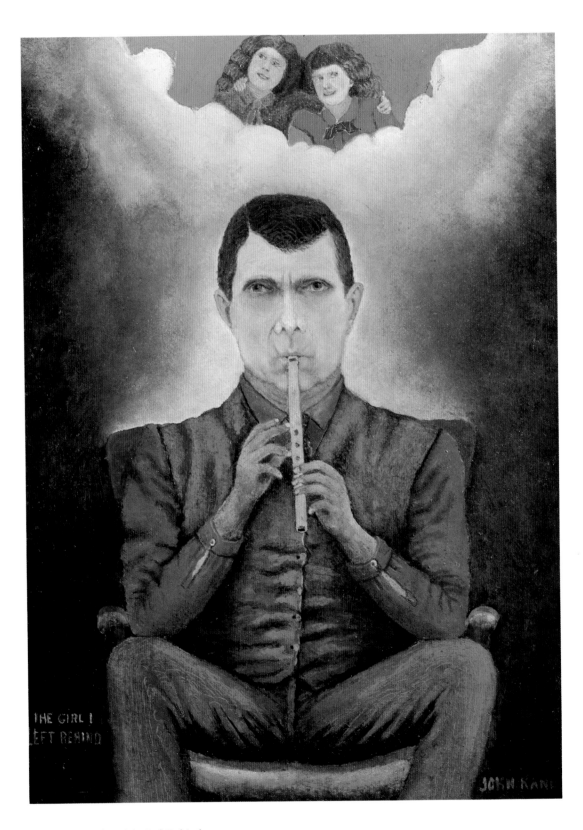

John Kane, *The Girl I Left Behind*, 1920
Oil, board, 15.375 x 11.125 inches

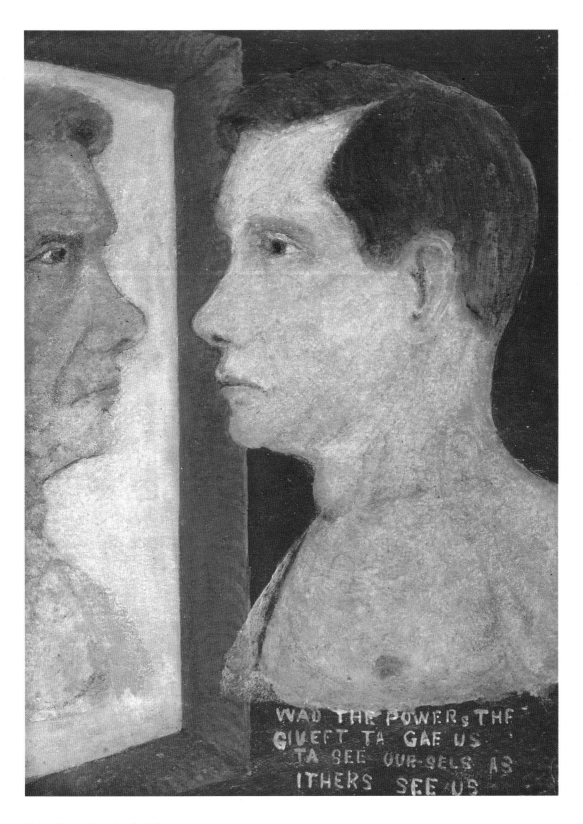

John Kane, *Seen in the Mirror,* 1928
Oil, canvas, 8.5 x 6.75 inches

49

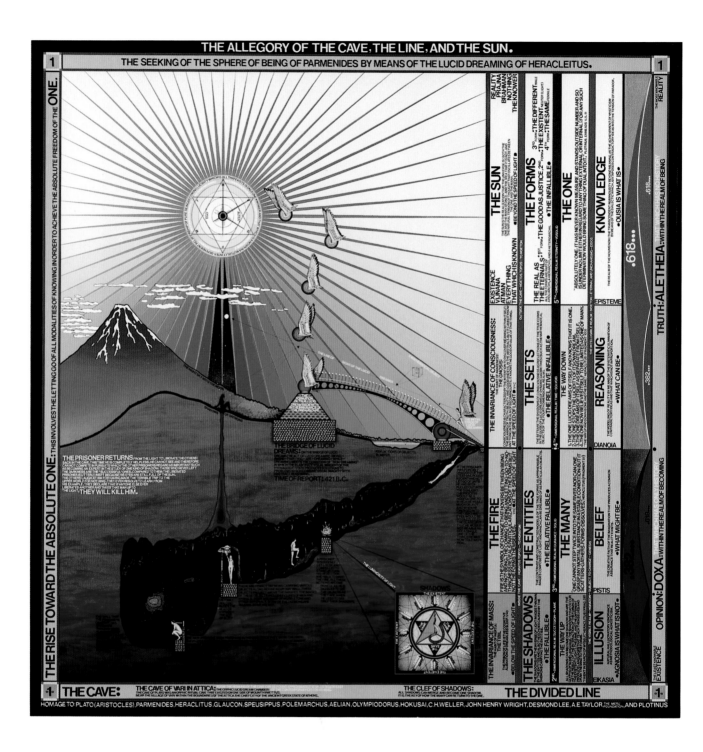

Paul Laffoley, *The Allegory of the Cave, the Line, and the Sun*, 1991
Oil, acrylic, letters, india ink, linen, 73.5 x 73.5 x 3.5 inches

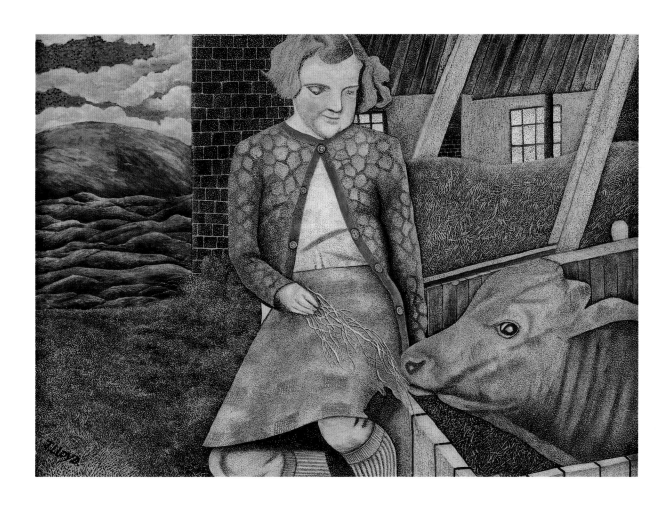

James Lloyd, *Girl with Cow,* ca. 1965
Gouache, paper, 10.75 x 15 inches

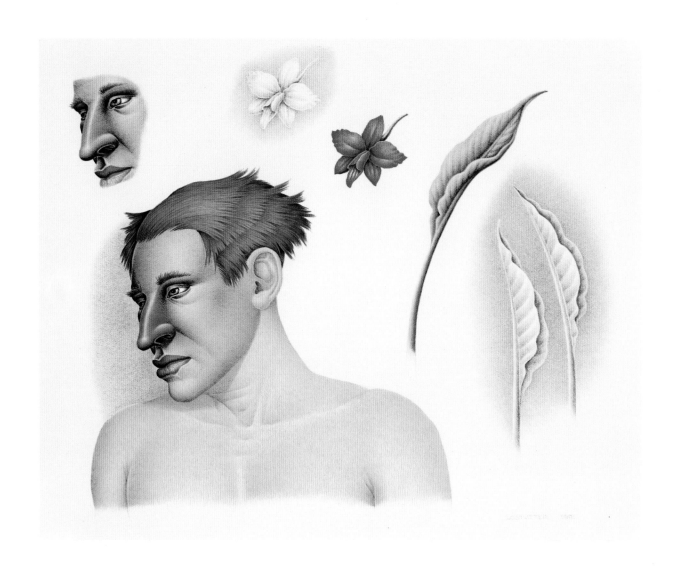

Robert Lostutter, *Untitled*, 1991
Pencil, watercolor, paper, 9 x 11 inches

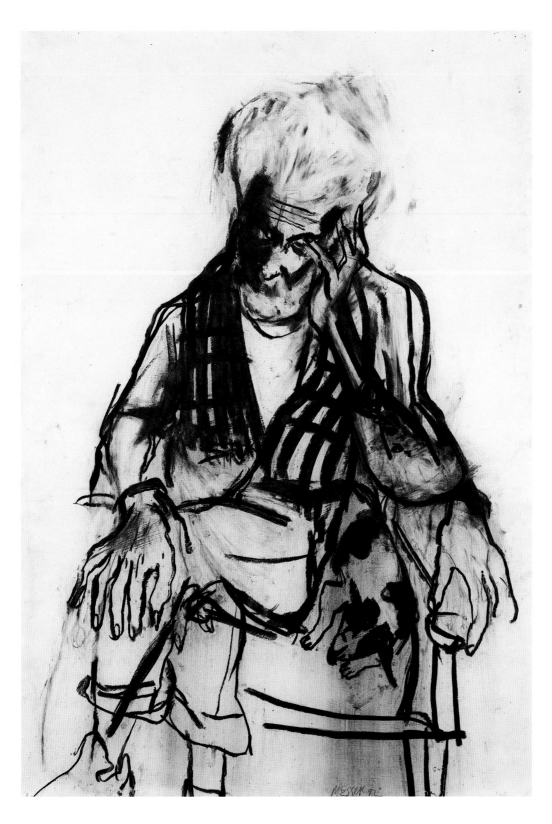

Sam Messer, *Sadness,* 1993
Charcoal, paper, 44 x 33 inches

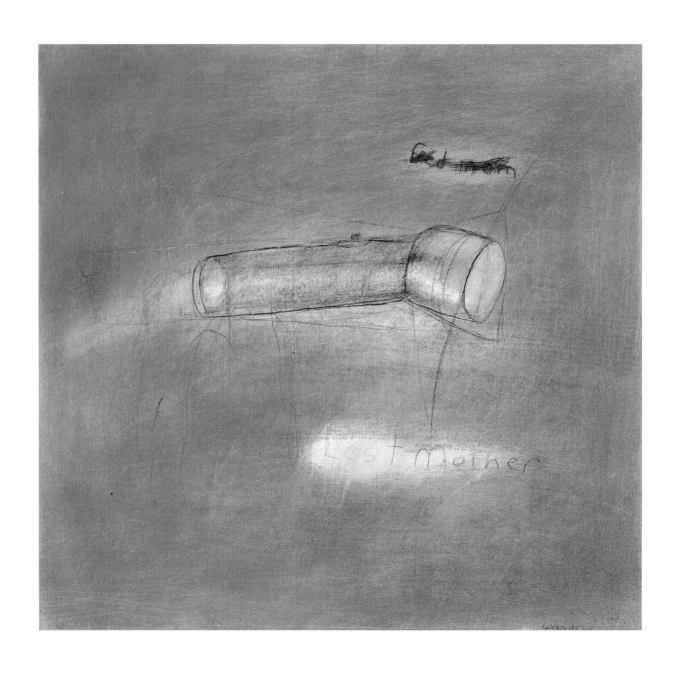

Wes Mills, *Untitled (Flashlight),* 1992
Dry pigment, gesso, board, 9 x 9 inches

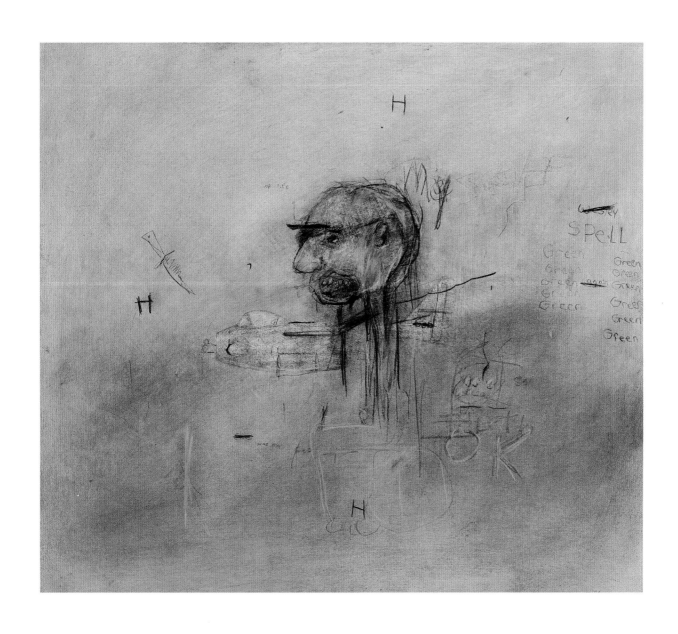

Wes Mills, *Myself, My Life*, 1992
Pencil, dry pigment, gesso, board, 13 x 14.75 inches

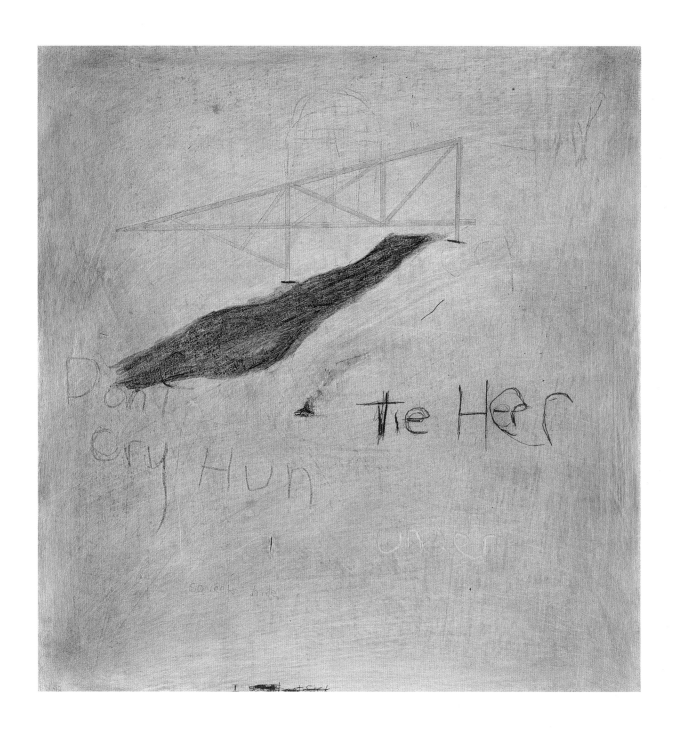

Wes Mills, *God Under the Bridge*, 1992
Dry pigment, gesso, board, 12.5 x 12 inches

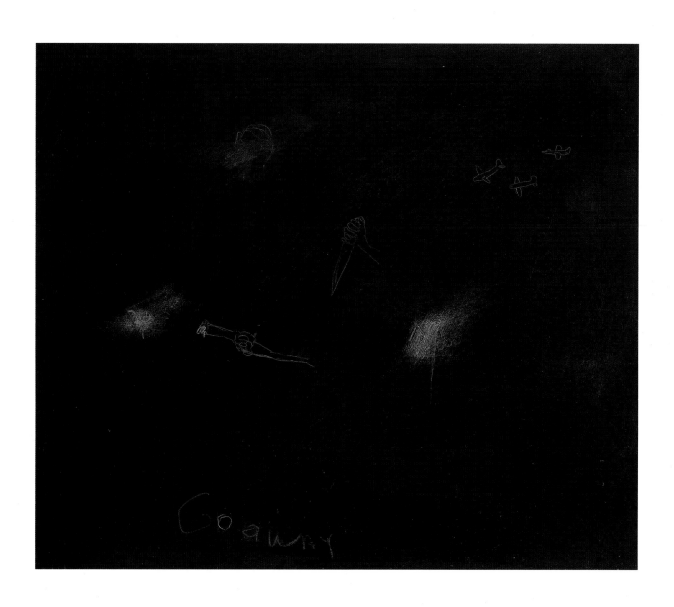

Wes Mills, *Go Away*, 1992
Dry pigment, gesso, board, 12.25 x 12 inches

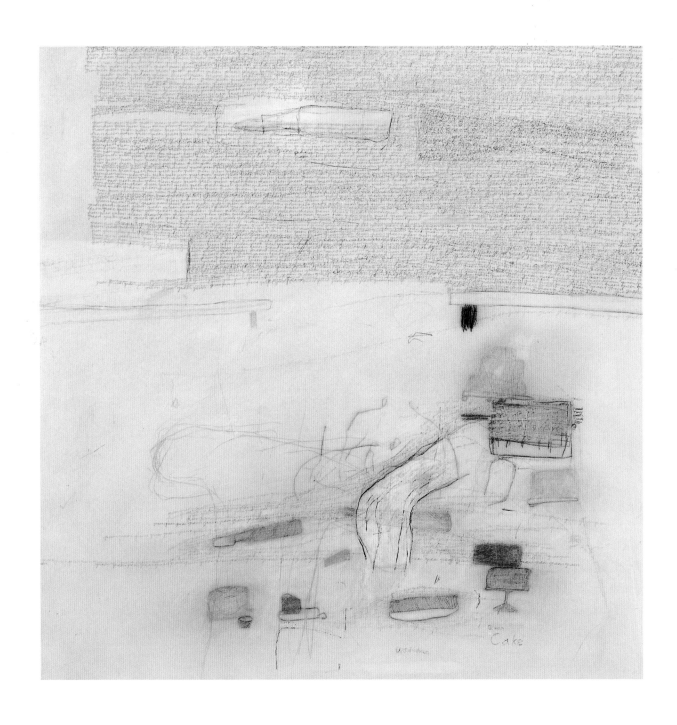

Wes Mills, *Untitled (Cake)*, 1993
Pencil, dry pigment, gesso, board, 12.5 x 11.875 inches

58

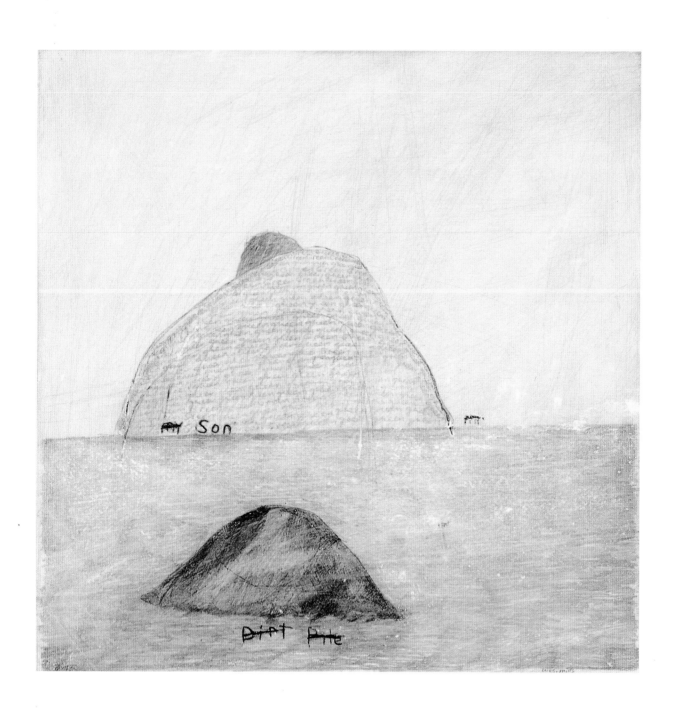

Wes Mills, *Untitled (Dirt Pile)*, 1993
Colored pencil, dry pigment, gesso, board, 9 x 9 inches

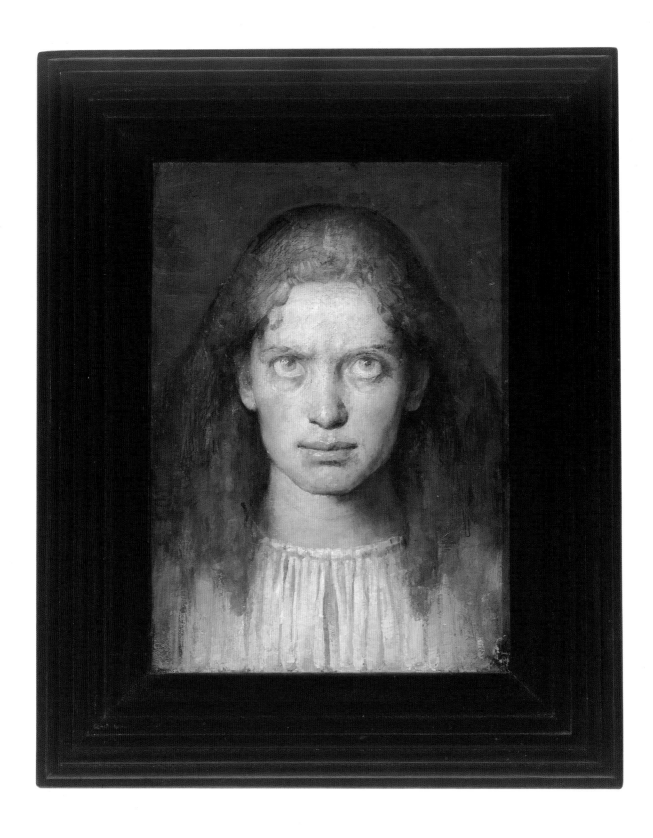

Odd Nerdrum, *Portrait of a Young Girl,* 1993
Oil, canvas, artist's frame, 22 x 17 inches

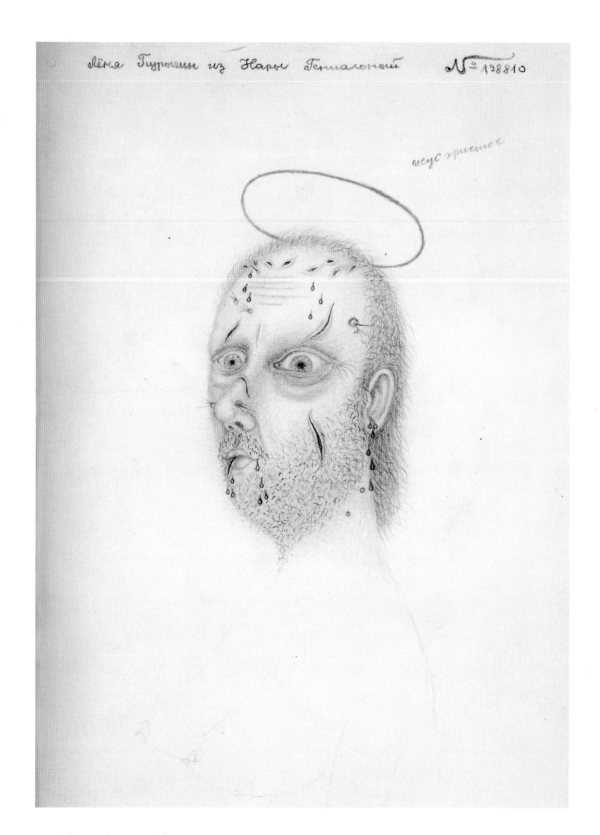

Leonid Purygin, *Untitled,* 1988
Graphite, colored pencil, paper, 14.5 x 13.5 inches

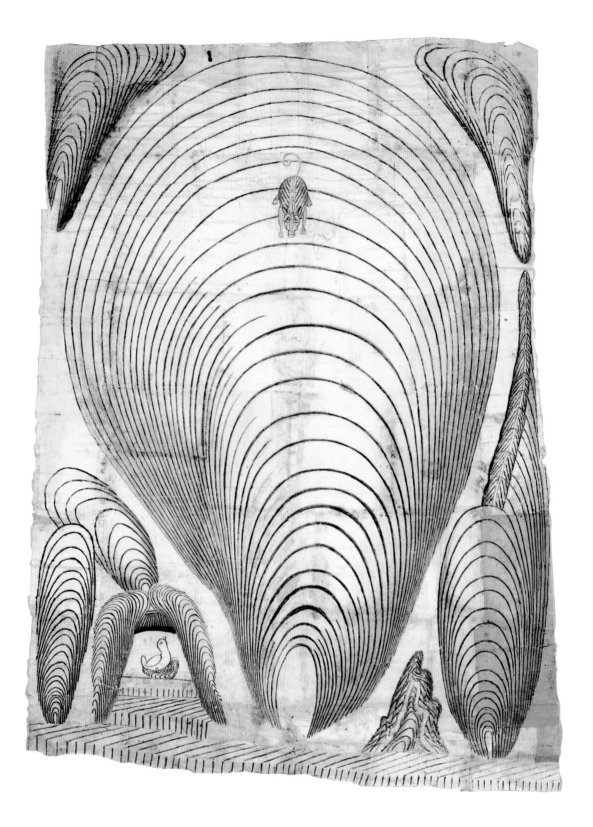

Martin Ramirez, *Untitled (Cat, Bird, and Tunnels)*, 1950
Ink, crayon, pencil, paper collage, 61 x 41.5 inches

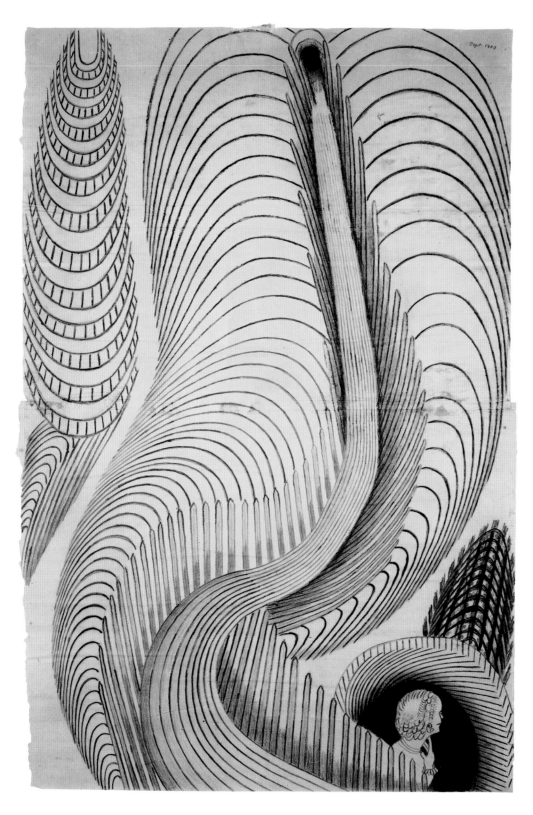

Martin Ramirez, *Untitled (Breck Girl)*, 1953
Crayon, pencil, paper, 46.25 x 30.5 inches

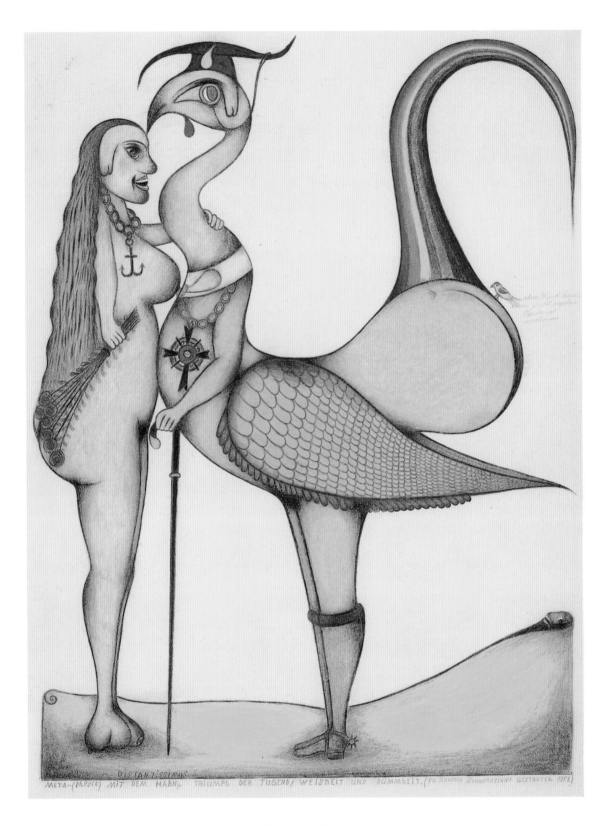

Friedrich Schröder-Sonnenstern, *Meta-(physik) mit dem hahn*, 1952
Graphite, colored pencil, paper, 12.5 x 9.5 inches

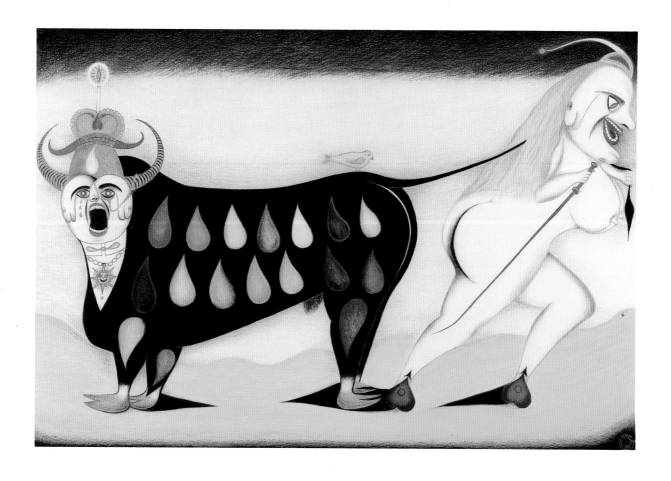

Friedrich Schröder-Sonnenstern, *Spruckelinchen mit Ihrem Wunderoschen Juckelche*, 1959
Colored pencil, paper, 19 x 28 inches

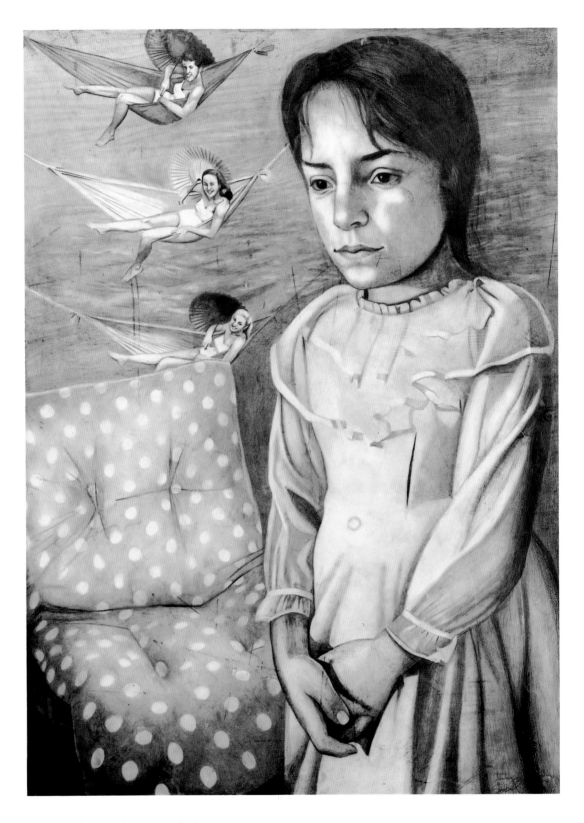

Jenny Scobel, *By the Sea, By the Sea*, 1995
Graphite, wax, wood panel, 33 x 24 inches

66

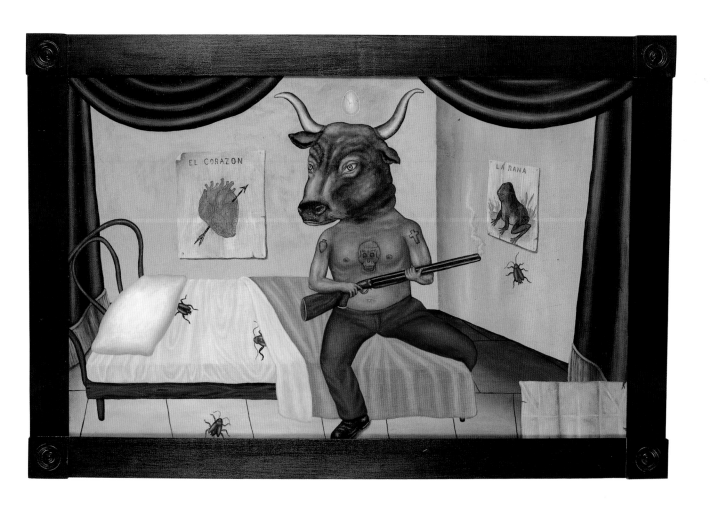

Fred Stonehouse, *Untitled*, 1994
Acrylic, panel, artist's frame, 32 x 48 inches

67

Myron Stout, *Teresias II*, 1965
Graphite, paper, 11.25 x 10.625 inches

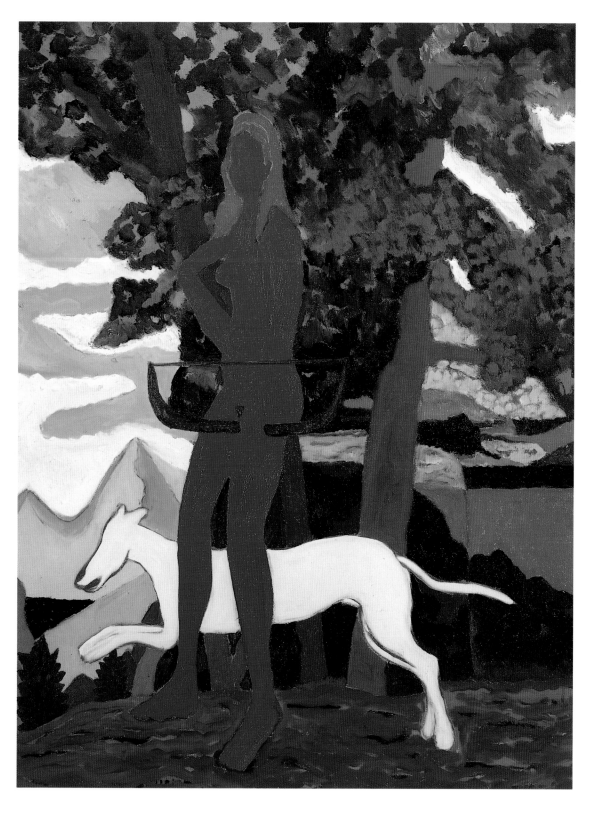

Bob Thompson, *Diana the Huntress*, 1965
Oil, canvas, 48 x 36 inches

69

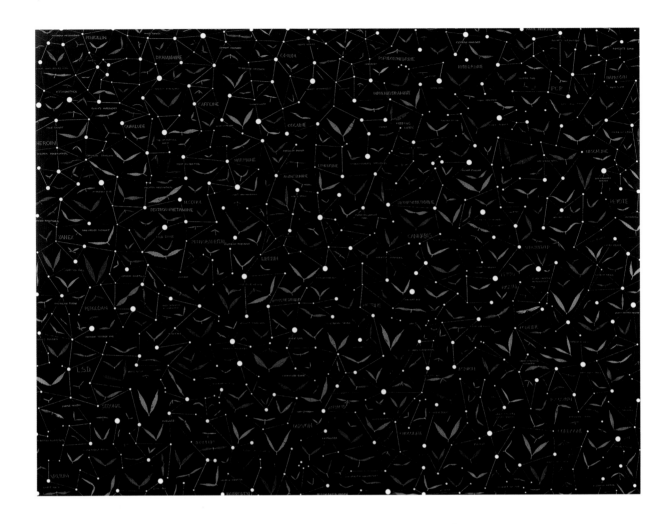

Fred Tomaselli, *All the Birds I Can Remember Seeing, All the Drugs I Can Remember Taking*, 1996
Hemp leaves, aspirin, acetaminophen, antacid, ephedrine, saccharin, prisma color, acrylic and
resin on wood panel, 54 x 72 inches

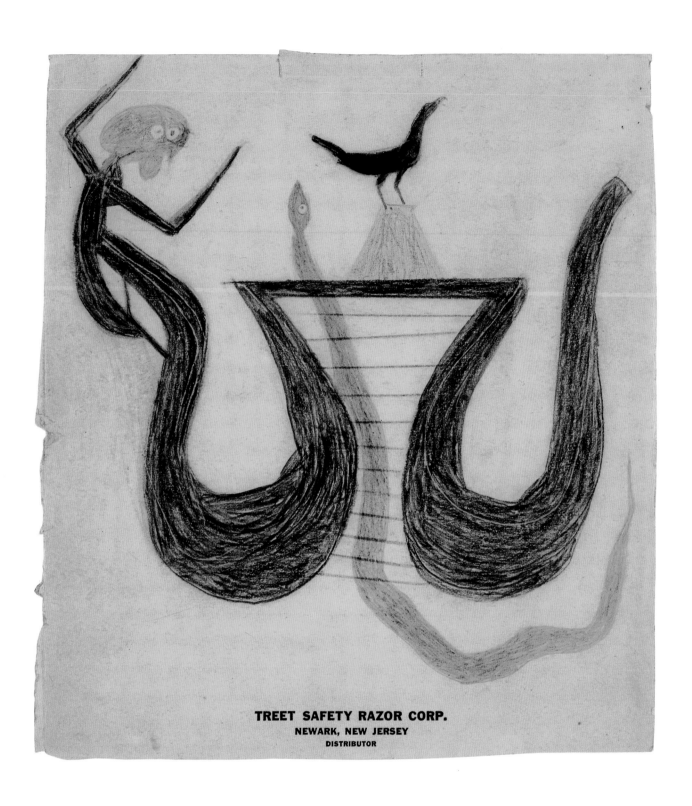

TREET SAFETY RAZOR CORP.
NEWARK, NEW JERSEY
DISTRIBUTOR

Bill Traylor, *Untitled*, ca. 1939-42
Pencil, crayon, cardboard, 111.5 x 10 inches

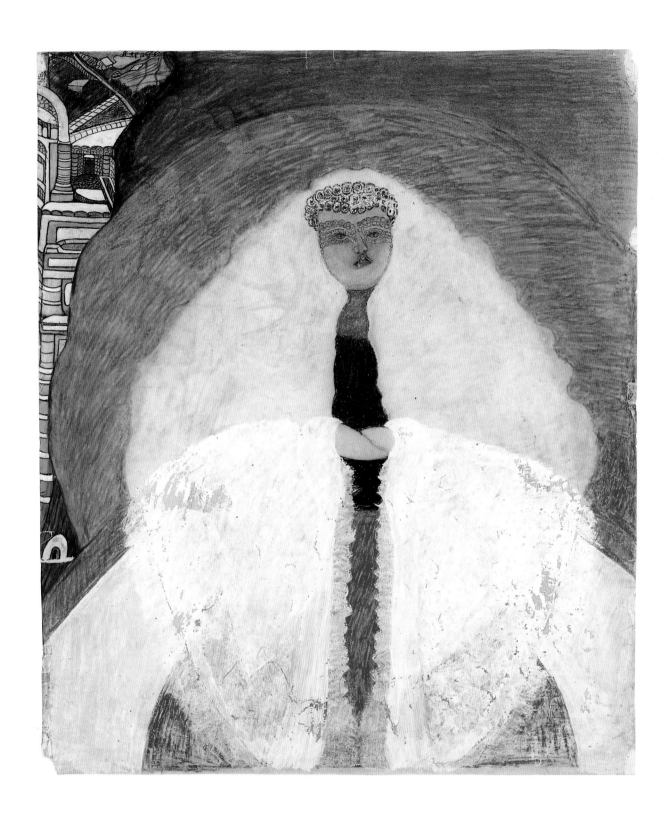

Perley M. Wentworth, *Untitled,* ca. 1950
Pencil, gouache, paper, 30 x 25.5 inches

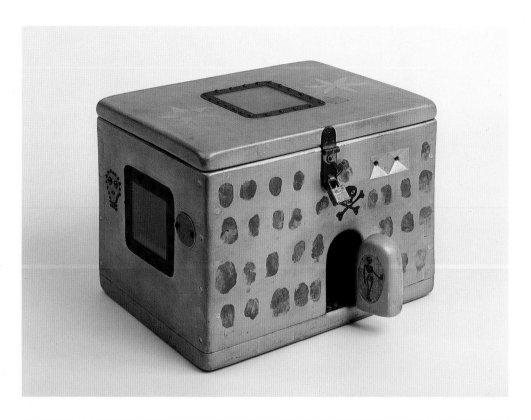

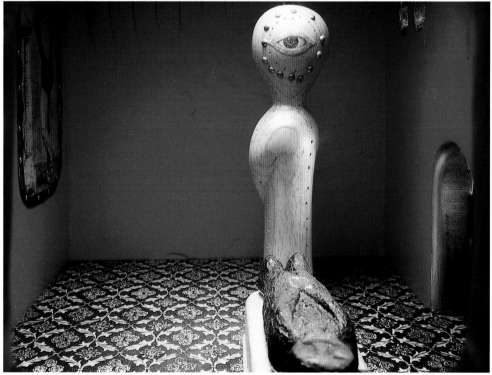

H.C. Westermann, *A Very Unusual Physician* (below, interior), 1995
Mixed media box construction, 8.5 x 12 x 9.75 inches

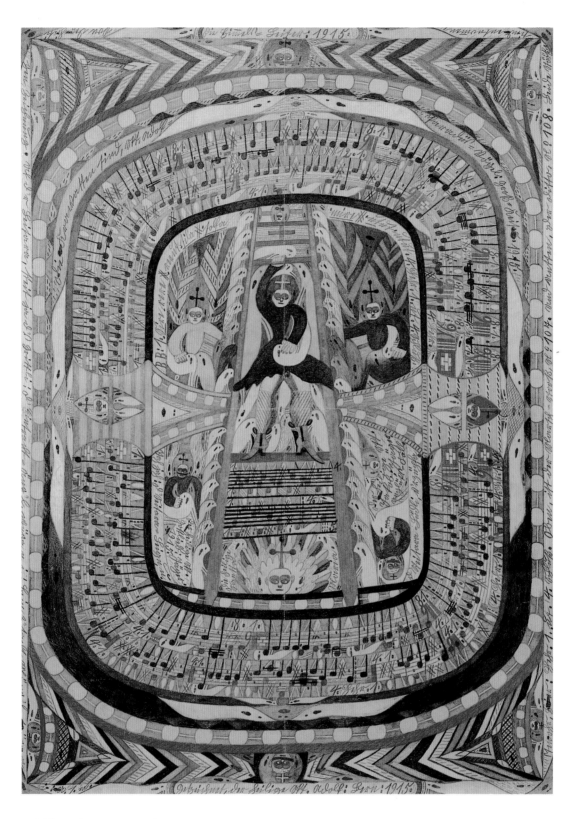

Adolf Wolfli, *Die Himmels Leiter*, 1915
Colored pencil, paper, 40 x 29 inches

74

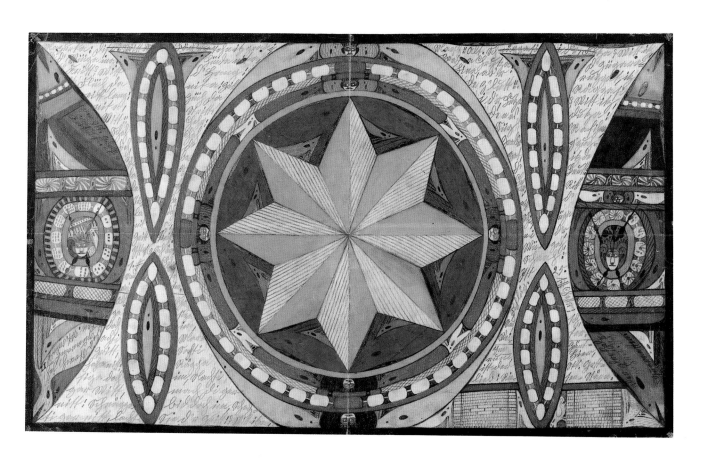

Adolf Wolfli, *D'r Amsel-Zorn,* 1923
Graphite, colored pencil, paper, 26 x 43 inches

75

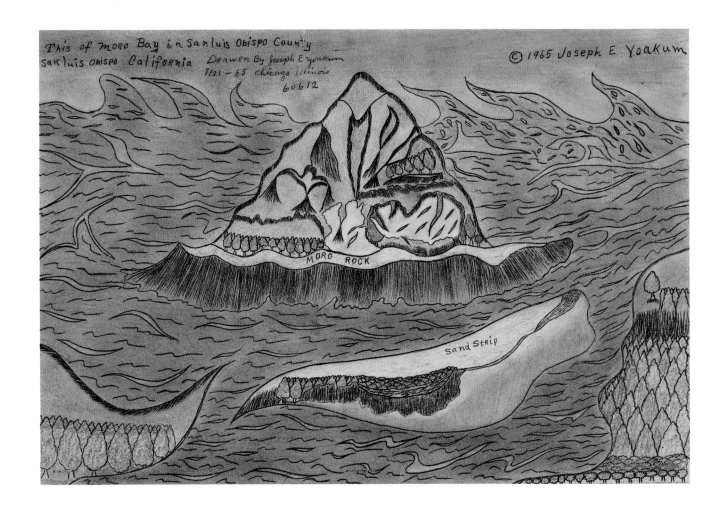

Joseph E. Yoakum, *This of Moro Bay*, 1965
Pencil, pastel, paper, 12 x 18 inches

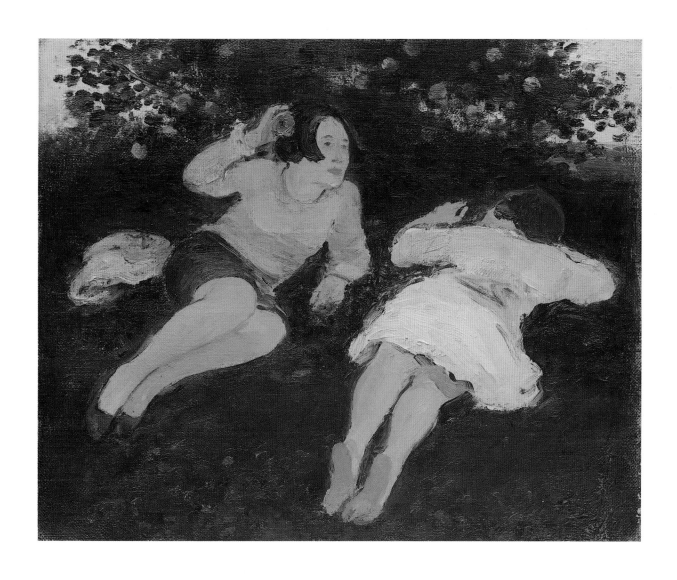

Albert York, *Two Reclining Women in Landscape,* 1967
Oil, canvas, 10 x 12 inches

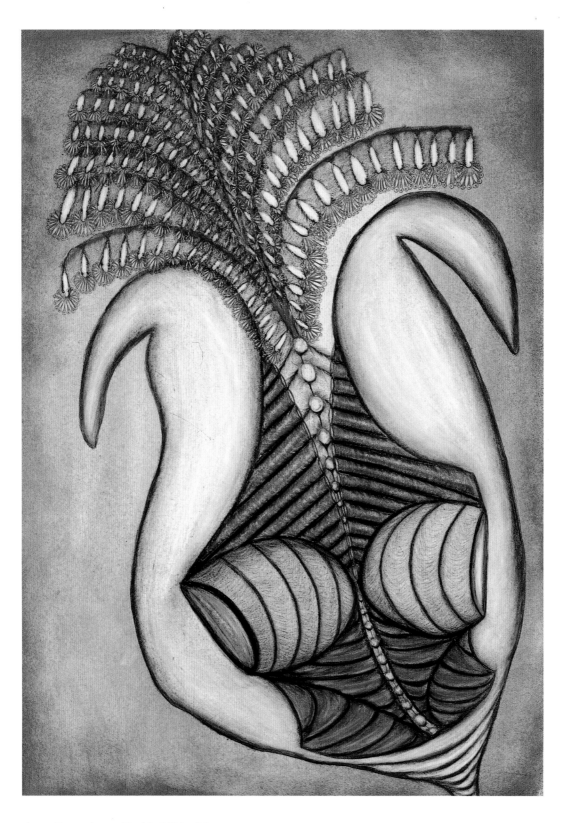

Anna Zemankova, *Untitled (Womb)*, 1960
Colored pencil, pastel, paper, 23.25 x 33.25 inches